600

WATERCOLOUR MIXES

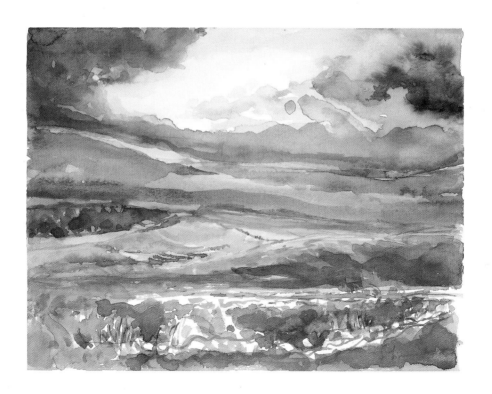

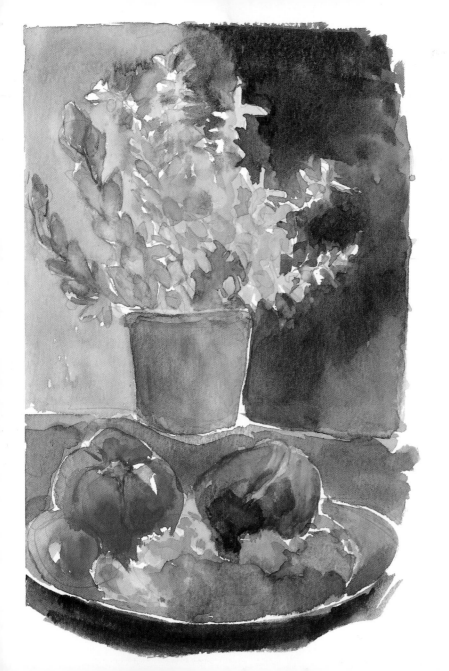

STORMY SKY

(PREVIOUS PAGE)

Very warm complementary colours were used in the foreground to convey a sense of distance. The sweep of Permanent Rose at the horizon lends drama to the scene.

FRUIT AND VEG

(LEFT)

Red and green create a wonderful contrast. Notice how just a touch of the red provides relief from the varieties of green.

600
WATERCOLOUR MIXES

SHARON FINMARK

BATSFORD

First published in the United Kingdom in 2011 by
Batsford
10 Southcombe Street
London W14 0RA

An imprint of Anova Books Company Ltd

ISBN 9781906388829

A CIP catalogue record for this book is available
from the British Library.

18 17 16 15 14 13 12 11
10 9 8 7 6 5 4 3 2 1

Repro by Mission Productions Ltd, Hong Kong
Printed by Times Publishing, Malaysia

This book can be ordered direct from the publisher at the
website www.anovabooks.com, or try your local bookshop.

CITY ROOFTOPS

Although composed of subtle earths and neutral colours,
the shadows are vital in this painting. They hint at the
complex labyrinth of streets and emphasize perspective,
especially from a 'bird's-eye' view.

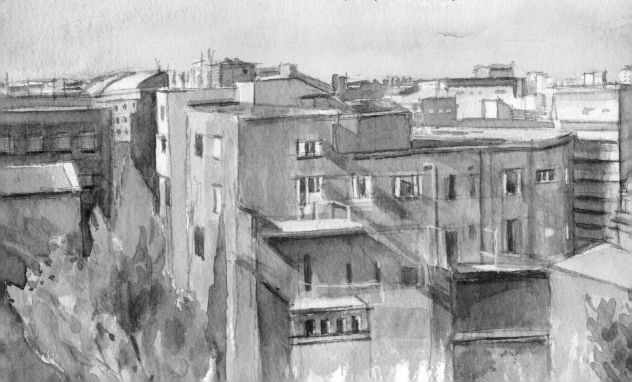

Contents

INTRODUCTION

A well-stocked art supplies shop can send a novice artist well-nigh dizzy with excitement. There will be ranks of beautiful brushes and a range of papers on display – and, of course, rows of tempting pigments in luscious colours. However, succumbing to the temptation to buy every colour that makes you itch to use it will not make you a good artist; that will come from learning how to use a much smaller palette with skill.

Understanding colour

Our response to colour is very personal, depending on our preferences. However, it is generally accepted that certain colours have a particular psychological impact on us, so to produce works that evoke an emotional response in the viewer an artist must understand how to use colour effectively.

With watercolour, you have access to a very versatile range of colours. A transparent quality can be achieved simply by diluting your pigment in water; with plenty of dilution you can produce the palest and most delicate of washes or you can choose instead to use the pigment straight from the tube to give intense, brilliant colours. The colours of the tubes or pans in your paintbox invite you to use them just as they are, but you will soon want to mix your own colours too.

A painting gains unity and coherence from a limited range of colours, so resist the temptation to buy a lot of pigments – it is better to choose carefully and mix the additional colours you need. You will see from the paintings in this book how wide a range you can achieve from just a few pigments.

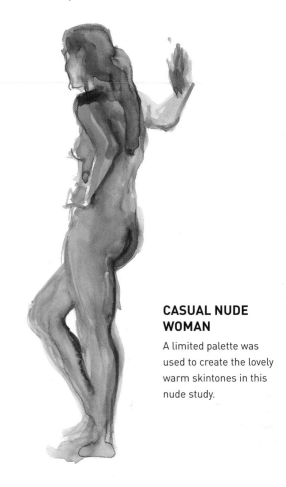

CASUAL NUDE WOMAN

A limited palette was used to create the lovely warm skintones in this nude study.

THE LANGUAGE OF COLOUR

The language used to describe paint is often confusing, but don't let that concern you too much – just practising and seeing what the colours produce will help to make everything clear. The terms below are ones you will commonly encounter.

Achromatic Lacking true colour; black, white and grey are considered to be achromatic, or neutral.

Adjacent/analogous The colours that neighbour each other on the colour wheel; for example, a colour scheme that used reds, oranges and yellows would be described as analogous.

Colour family Colours of the same hue, such as the range of reds or blues.

Complementary The colours that are opposite each other on the colour wheel, such as yellow and violet (see page 28).

High key/low key Bright, light colours are described as high key; subdued, dark ones are low key (see page 150).

Hue The name of the colour, such as yellow or blue.

Monochromatic A painting made with just one colour in different tonal values. In traditional watercolours a painting was often begun using only browns and was then overlaid with colour. Today, a monochromatic underpainting is more commonly used in oils and acrylics.

Neutral Greys, browns, earth colours and similar mixes are known as neutrals (see page 142).

Saturation The intensity of a colour.

Shade A darker colour of the original hue.

Tint A colour lightened with white. This is more often used in gouache, acrylics and oils. Watercolours work better applied transparent and luminous, so the paint is usually made a lighter colour by adding water.

Tone The lightness or darkness of a colour. Some colours will always be lighter than others; the deepest yellow will not be as dark as a deep blue, for example, but a paler blue can be the same tone as a yellow.

Value How light or dark in tone a colour appears.

Three ways of mixing watercolours

Most watercolour paintboxes contain two pigments in each primary colour – red, yellow and blue – one in a warm and one in a cool version. The concept of warm and cool colours is an important one, as it is fundamental to successful colour mixing. Cadmium Red, Cadmium Yellow and Ultramarine are warm, while Alizarin Crimson, Prussian Blue and Lemon Yellow are cool (see page 18). These are the colours you should get to know best and the ones you should use for your first experiments in colour mixing.

There are three different ways for artists to mix watercolours, each producing a different effect.

1. PALETTE MIXING

By mixing pigments in the palette you can make a graduated range of colours, influencing them by altering the proportions of the colours in the mix. When you mix two primary colours together the resulting mix is a secondary (see page 19).

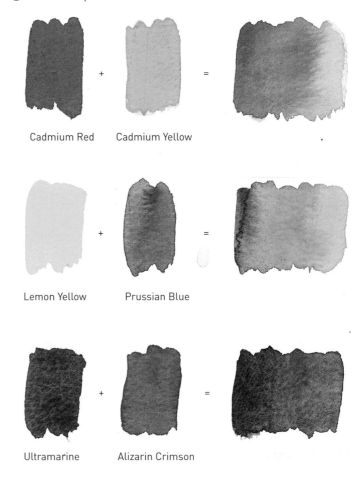

Cadmium Red Cadmium Yellow

Lemon Yellow Prussian Blue

Ultramarine Alizarin Crimson

| Cadmium Red + Cadmium Yellow | Lemon Yellow + Prussian Blue | Ultramarine + Alizarin Crimson |

2. OVERLAYING

In this method of mixing, a glaze of one colour is laid over a dry area of another colour to produce the new colour.

| Cadmium Red + Cadmium Yellow | Lemon Yellow + Prussian Blue | Ultramarine + Alizarin Crimson |

3. WET-INTO-WET

The third way of mixing is also on the paper, but on damp or wet paper so that one colour merges into the other. Where they meet they produce a new colour.

1 YOUR BASIC PALETTE

The key to handling colour well is to begin by exploring a basic range of colours to see what they offer you in various mixes and dilutions – there is no better way to gain the confidence that will help you to paint with fluency right from the early stages of learning. When the pigments begin to seem like familiar friends you can then enjoy extending the range with some extra colours to see what they will contribute.

Arranging your palette

In a paintbox the colours are usually arranged by colour family, with the ranges of reds, blues, yellows and greens grouped together, and so on. If you have tubes and need to squeeze the paint out on a separate palette, place them in the same order so that you can find them without hesitation. You will not want to waste a moment looking for the pigment you need when you are working wet-into-wet, particularly if you are working outside on a hot and sunny day when the paint is drying fast.

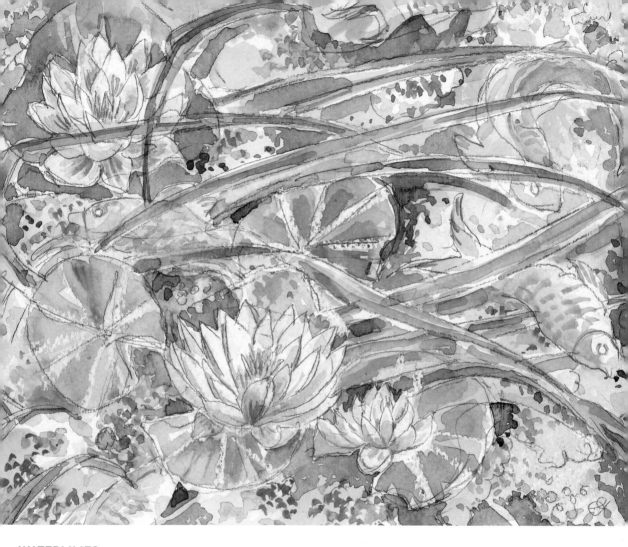

WATERLILIES

The fish were painted in Cadmium Yellow, with Cadmium Orange used to emphasize the scales. The leaves are Hooker's Green, with a hint of Prussian Blue to create shadows.

Basic colours

A basic set of tubes or pans will usually contain Lemon Yellow, Cadmium Yellow, Cadmium Orange, Cadmium Red, Alizarin Crimson, Violet, Ultramarine, Prussian Blue, Hooker's Green, Viridian, Burnt Sienna and Vandyke Brown or the manufacturer's own versions of these colours.

A larger set may also offer Permanent Rose, Yellow Ochre, Payne's Grey, Naples Yellow, Raw Umber, Burnt Umber, Sap Green, Cerulean and Cobalt Blue. In addition, a black and a white may be included. The former can be used to darken colours, but it should not be relied on as the main principle of watercolour is keeping transparency a priority. The dilutions that can be produced from this basic palette

of colours are shown on pages 14–15, while an extended range of paint colours and information about each colour's uses is on pages 16–17.

Before you set about mixing pigments to produce another colour from your set, assessing the value of the colours is the very first step. Some are initially dark in value, such as the blues, while some are light, such as the yellows. Watercolour pigments are lightened by diluting them with water in the desired quantity. The mid-value colours can be darkened within the same colour family – for example, a shadowed area on a tomato could be painted in Alizarin Crimson over the main colour of Cadmium Red, once it has dried.

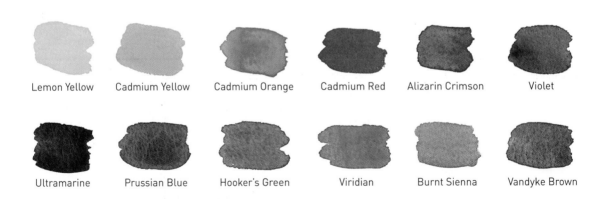

| Lemon Yellow | Cadmium Yellow | Cadmium Orange | Cadmium Red | Alizarin Crimson | Violet |

| Ultramarine | Prussian Blue | Hooker's Green | Viridian | Burnt Sienna | Vandyke Brown |

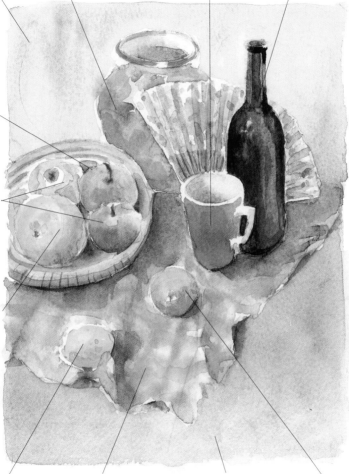

Prussian Blue into
a wet area of paper

Prussian Blue, Hooker's
Green and Cadmium
Yellow mixed on wet paper

Violet with an overlaid
glaze of Ultramarine

Ultramarine with overlaid
glazes of Violet

Cadmium Yellow
with overlaid glazes
of Cadmium Red

Hooker's Green
with overlaid glazes
of Vandyke Brown

Cadmium Yellow
with overlaid glazes
of Hooker's Green

Lemon Yellow with
overlaid glazes of
Hooker's Green

Alizarin Crimson
on to damp paper

Violet and Vandyke
Brown into a wet
area of paper

Cadmium Yellow
with overlaid glazes
of Cadmium Orange

STILL LIFE: FAN, BOTTLE AND FRUIT

PALETTE USED

Lemon Yellow
Cadmium Yellow
Cadmium Orange
Cadmium Red
Alizarin Crimson
Violet
Ultramarine
Prussian Blue
Hooker's Green
Vandyke Brown

Dilutions

Diluting pigments with water has the effect of lightening the colour and producing the delicate washes for which watercolour is renowned. Here each basic colour is shown in gradually increased dilutions to show the range of tones that can be obtained, from the pure colour to the palest tint. This versatility means that a delicate flowerhead could be painted in dilutions of just one colour, for example.

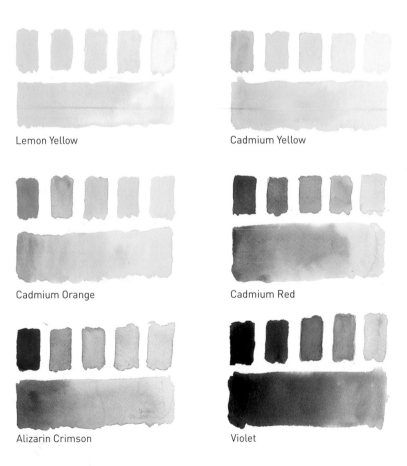

Lemon Yellow

Cadmium Yellow

Cadmium Orange

Cadmium Red

Alizarin Crimson

Violet

The fluidity of the paint is vital to the appearance of a watercolour painting – it should look transparent and effortless in its application. Obtaining a range of tints such as those on this spread is just a matter of careful handling of the proportions of water and paint to make subtle adjustments.

Using more water in the dilution means that you can cover larger areas of the painting with generous sweeps of colour, ideal for areas such as big skies. Always prepare plenty of the dilution – if you have to pause part of the way through to mix more paint and water you will lose the smoothness of the wash.

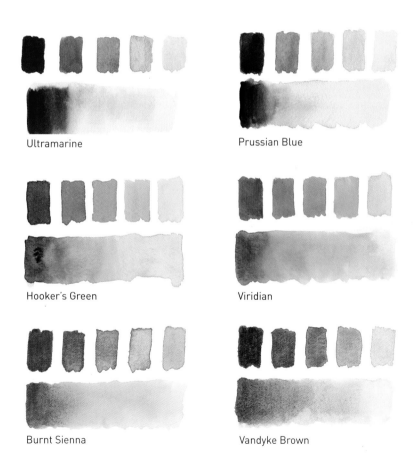

Ultramarine

Prussian Blue

Hooker's Green

Viridian

Burnt Sienna

Vandyke Brown

Extending the range

A few extra colours are a bonus to your basics. Some sets include Permanent Rose, Payne's Grey, Yellow Ochre, and a black and a white, but if yours does not you can simply buy extra pans or tubes.

Permanent Rose is a very intense cool red similar to Alizarin Crimson and is excellent for the purples and pinks often found in flowerheads. Both reds are so strong that if you try to lift them off with a sponge, whether to correct a mistake or to create a special effect, you will find they have penetrated the fibres of the paper, thus leaving traces of colour behind.

Yellow Ochre is a paler earth colour than Burnt Sienna but is more opaque and thus has greater covering power. Mix it with a delicate touch.

Payne's Grey is a cool grey, useful if you are struggling to mix a neutral. Be aware, though, that using it rather than making your own mix can become too tempting – remember that not all shadows are Payne's Grey.

The use of black in watercolour is often disparaged, but when black is mixed with other colours, also sparingly, it can produce a wealth of slightly muted colours (see page 148).

In watercolour painting white is usually produced by leaving the paper untouched, but occasionally an area of pearly, more opaque colour is perfect among the transparent washes. Certainly Constable and Turner used that effect in their rapid watercolour sky and cloud sketches.

Permanent Rose

Yellow Ochre

Payne's Grey

Black

Chinese White

FLOWERS AND FRUIT

PALETTE USED
Cadmium Yellow
Cadmium Orange
Cadmium Red
Alizarin Crimson
Violet
Prussian Blue
Permanent Rose
Yellow Ochre

Violet on wet paper

Strokes of Prussian Blue on dry paper

Overlaid glazes of Permanent Rose

Cadmium Yellow and Yellow Ochre on wet paper

Cadmium Red on dry paper

Diluted Cadmium Red and Cadmium Yellow on wet paper

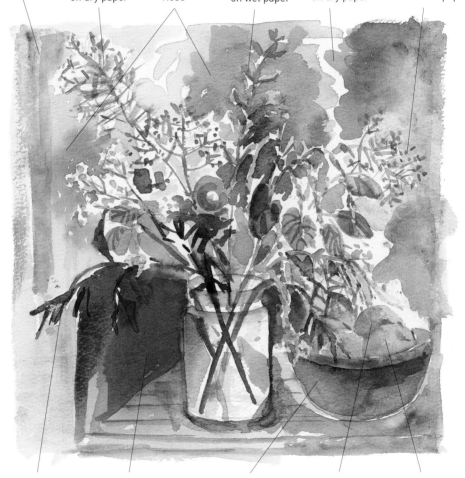

Alizarin Crimson and Violet strokes on dry paper

Violet, Cadmium Red and Alizarin Crimson mixed on wet paper

Prussian Blue with overlaid glazes of Cadmium Yellow and Yellow Ochre

Cadmium Yellow with overlaid glazes of Cadmium Red

Cadmium Yellow with overlaid glazes of Cadmium Orange

Primary colours

The primary colours in your set of paints are the reds, blues and yellows, which cannot be mixed from other colours. In most small paintboxes there are usually two of each primary, plus some of the earth colours, such as the umbers and siennas.

Each of the primary pigments will be supplied in one warm colour and one cool colour; while red is considered to be a hot colour and blue is cool, for example, they will have a bias towards the adjacent colour on the colour wheel which determines just how warm or cool they are. This property is worth exploiting when you are painting to create space and distance, since warm colours advance while cool ones recede.

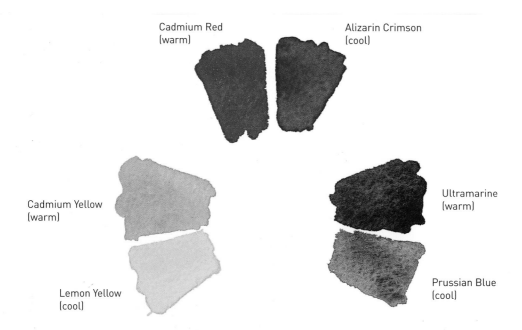

Cadmium Red
(warm)

Alizarin Crimson
(cool)

Cadmium Yellow
(warm)

Ultramarine
(warm)

Lemon Yellow
(cool)

Prussian Blue
(cool)

Secondary colours

When primary colours are mixed together they create secondary, or complementary, colours – orange, violet and green. Most watercolour paintboxes also contain several premixed secondary colours, such as Violet, Viridian and Hooker's Green.

There are subtle differences in the secondaries produced from the warm or cool versions of each of the primaries. By taking advantage of these you can influence the viewer's perception of your painting.

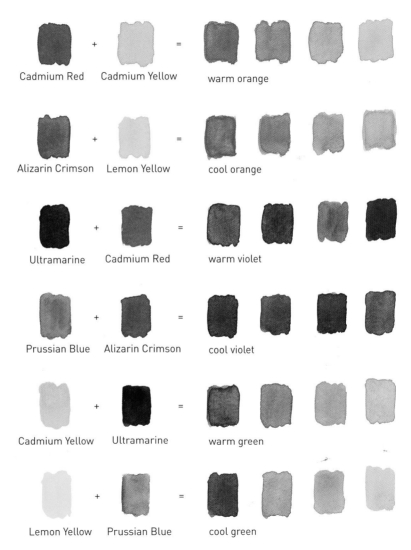

Cadmium Red + Cadmium Yellow = warm orange

Alizarin Crimson + Lemon Yellow = cool orange

Ultramarine + Cadmium Red = warm violet

Prussian Blue + Alizarin Crimson = cool violet

Cadmium Yellow + Ultramarine = warm green

Lemon Yellow + Prussian Blue = cool green

Tertiary colours

A tertiary colour could also be called an intermediary colour because it is made by mixing an approximately equal quantity of a primary colour with the secondary next to it on the colour wheel (see pages 22–23). For example, if you combine red with its neighbour to the right – orange – you obtain red-orange; if you combine red with violet, its neighbour to the left, a red-violet is the result.

You can create further intermediary colours by repeatedly mixing each neighbouring pair until you have almost continuous subtle transitions of colour. These pairings could be further divided to produce even more nuanced gradations by slightly increasing the bias towards one or other of the component colours. On any section of the wheel, the run of adjacent colours forms a harmonious relationship (see pages 24–25).

The infinite progression is in itself a beautiful image. Think how gardens with flowerbeds of closely connected colours are a delight to the eye – you can use these colours equally sensitively and constructively in a painting.

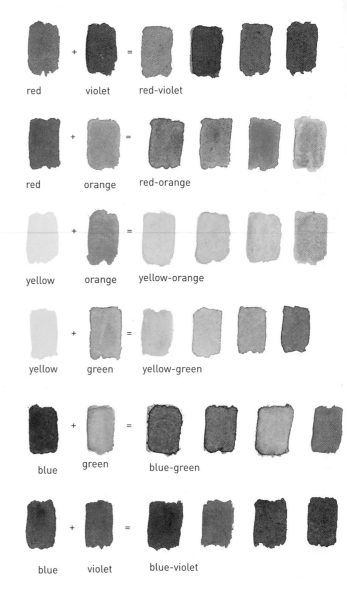

red violet red-violet

red orange red-orange

yellow orange yellow-orange

yellow green yellow-green

blue green blue-green

blue violet blue-violet

Ultramarine and
Alizarin Crimson mixed
to make blue-violet.

Alizarin Crimson and
Ultramarine mixed to
make red-violet.

Cadmium Yellow and
Cadmium Red mixed to
make yellow-orange.

Alizarin Crimson and
Ultramarine mixed
to make red-violet.

BACK GARDEN

PALETTE USED

Lemon Yellow
Cadmium Yellow
Cadmium Red
Alizarin Crimson
Ultramarine
Prussian Blue

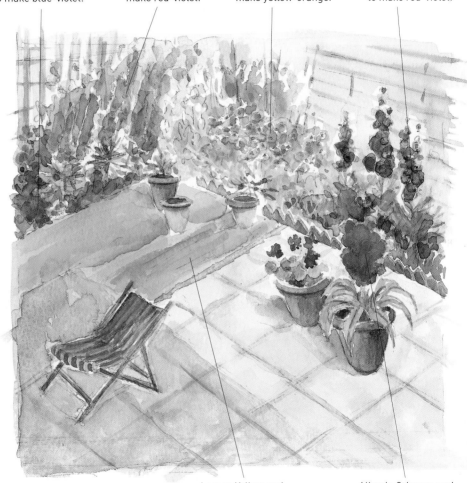

Lemon Yellow and
Prussian Blue mixed to
make yellow-green.

Alizarin Crimson and
Lemon Yellow mixed to
make red-orange.

2 COLOUR RELATIONSHIPS

Colours are never seen in isolation. If you just put a dab of the same colour on two pieces of paper, one white and the other tinted, you will see immediately how they look quite different. It is clear then that when it comes to handling several colours together you will need to have an understanding of how they will react with each other and the effect this will convey to the viewer.

Colour wheel

The traditional way of showing the colour spectrum is to organize colours into a wheel, showing where the colours sit and the relationships between them. The principles demonstrated will help you to use colour to the best effect in your paintings.

On the colour wheel, the primary colours (see page 18) are positioned at equal distances apart, with each secondary colour (see page 19) between the two primaries from which it is mixed and opposite the third primary: thus, violet, mixed from blue and red, is opposite yellow; green, mixed from yellow and blue, is opposite red; and orange, mixed from red and yellow, is opposite blue.

In between are the tertiary colours (see page 20), which are a subtle gradation of the mixture between the primary and the secondary, in other words red-orange, yellow-orange, yellow-green, blue-green, blue-violet and red-violet.

Although each of the primary colours is unlike the others, they become related to each other by the intermediary 'mixed' colours. So a painting with red and blue, which would stress the contrasting properties of those colours, could be unified by adding the intermediary red-violets and blue-violets to make a clever colour link.

The complementaries (see page 28) are completely unlike each other, so they create a very strong contrast and tend to intensify each other. If the complementaries are the same saturation, or strength of colour, they can produce a vivid optical impact.

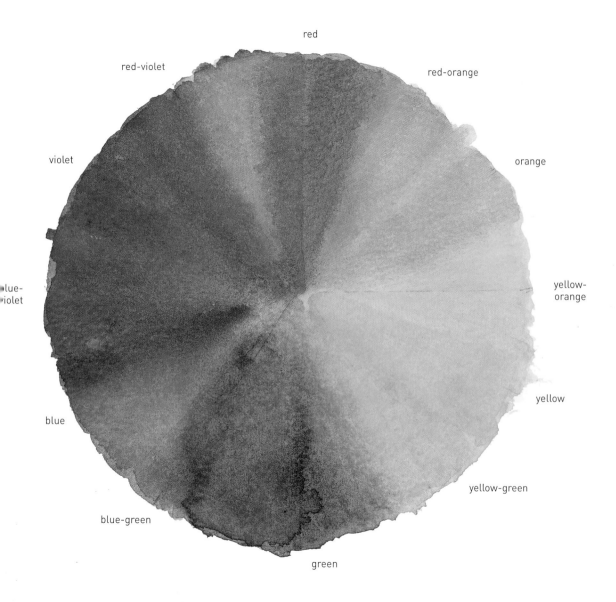

red

red-violet red-orange

violet orange

blue-
violet yellow-
orange

yellow

blue yellow-green

blue-green

green

Harmonious colours

To paint in harmonious colour is to work with the range of colours that are adjacent to each other on the colour wheel – for example the range from dark orange through red to violet, from light green through yellow to orange, or from cool blues to deep greens.

Using colour in this way, known as 'adjacent harmony', unifies a composition. Assembling objects for a still life that all share a colour association will pull a painting together, and while you cannot set up the elements in a landscape in the same way, you can decide which colours you use to paint them.

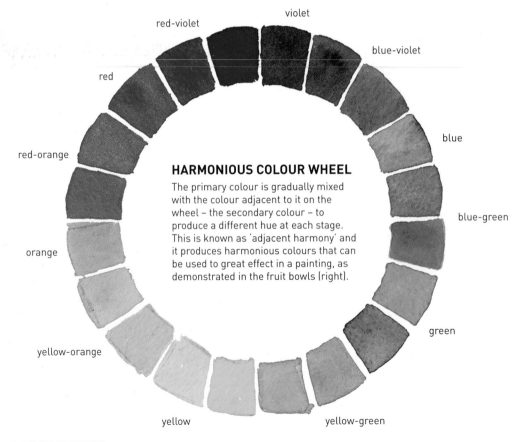

HARMONIOUS COLOUR WHEEL

The primary colour is gradually mixed with the colour adjacent to it on the wheel – the secondary colour – to produce a different hue at each stage. This is known as 'adjacent harmony' and it produces harmonious colours that can be used to great effect in a painting, as demonstrated in the fruit bowls (right).

red-violet
violet
blue-violet
red
blue
red-orange
blue-green
orange
green
yellow-orange
yellow-green
yellow

The simplest harmony is produced by mixing two hues. Placing the resultant hue in between them creates a common bond that unifies the initial hues. Harmony also occurs if hues have the same tonal value or saturation or if a dominant colour unites a range of tints and shades.

Here the family of reds is used, from the cool bluish Alizarin Crimson to orange-biased Cadmium Red

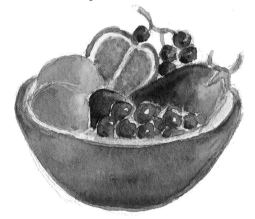

The colours in this bowl of fruit range from greenish Prussian Blue to warm Ultramarine and Violet

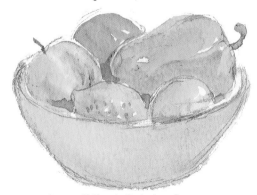

Lemon Yellow to Cadmium Orange are the colours used from cool to warm within the same harmonious family

This study in greens is produced from mixes of colours ranging from warm Sap Green to cool Viridian

Harmony in practice

In the paintings and vignettes on this spread you can see how using a palette of colours adjacent on the wheel brings unity and coherence to a composition.

The viewer's eye makes the connections between the colours and travels round the painting, guided by the linking of the hues.

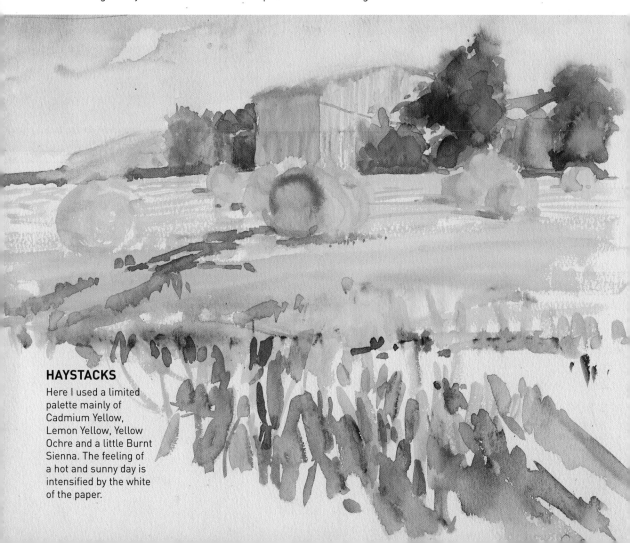

HAYSTACKS

Here I used a limited palette mainly of Cadmium Yellow, Lemon Yellow, Yellow Ochre and a little Burnt Sienna. The feeling of a hot and sunny day is intensified by the white of the paper.

FLAMING SCARVES

Although I used mainly
Alizarin Crimson, Cadmium
Red and Permanent Rose
for these scarves I added
a touch of reddish violet
to add a tiny contrast.

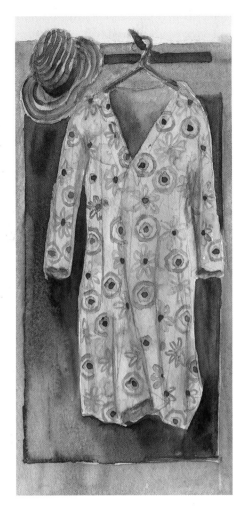

SUMMER BLUES

This dress features a variety of blues
and violets, all in the same band of
harmonious hues – Ultramarine,
Prussian Blue, Cerulean, Cobalt Blue,
Violet and a touch of Alizarin Crimson.

GREEN LEAVES

The tree and foliage were
painted in Hooker's Green,
Lemon Yellow and Viridian,
with a touch of red used in
the dark areas.

Complementary colours

Understanding the position of colours on the colour wheel is crucial to enhancing your paintings. Opposite colours are called complementary – they complement each other and gain more brilliance by virtue of their juxtaposition.

The complementary of a primary colour is always a secondary colour which is a mixture of the other two primaries. Therefore, red is complementary to green (mixed from blue and yellow); yellow is complementary to purple (mixed from blue and red); and blue is complementary to orange (mixed from yellow and red).

Even a little of a complementary colour catches the eye and brings a painting to life. Constable liked to put a dash of red amid the greens of a landscape, and although it was often just a brushmark that

Complementary red and green Complementary blue and orange Complementary yellow and purple

represented nothing in particular he regarded it as playing such a strong role in a painting that he called it 'the little red soldier'.

Heightening a composition with the use of complementary colours has a strength and impact on mood different from the subtle effect of the harmonious colours on pages 24–27. This is called 'contrasting harmony'. To take it further you can exaggerate the effect by, for example, using a very yellow green for trees and a purple grey for the shadows. Although this is not the reality of what you see, you will make an exciting painting which will have tremendous impact. In still life set-ups, try to choose objects in complementary colours as on pages 30–31, again exaggerating and altering where necessary to make the colours sing.

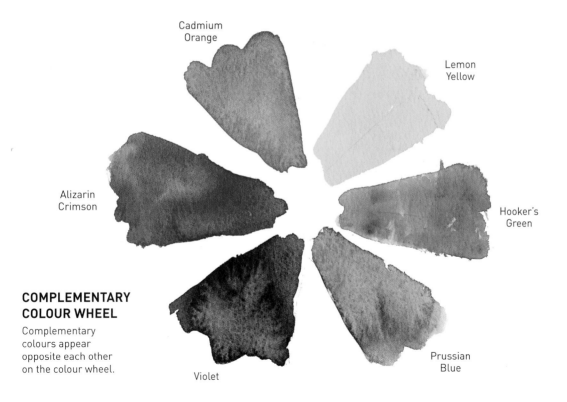

Cadmium Orange

Lemon Yellow

Alizarin Crimson

Hooker's Green

COMPLEMENTARY COLOUR WHEEL

Complementary colours appear opposite each other on the colour wheel.

Violet

Prussian Blue

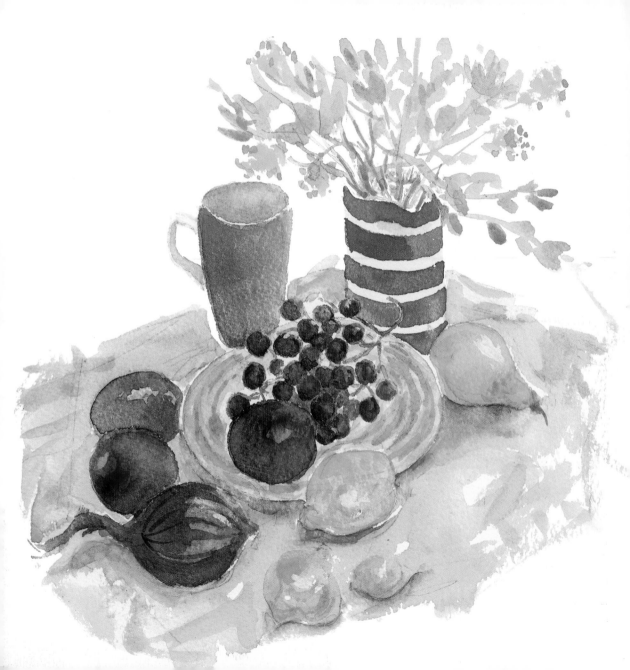

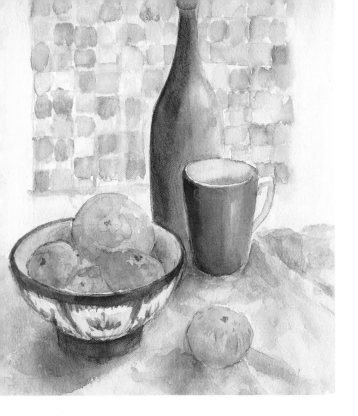

ORANGES AND BLUE BOTTLE

This still life exploits how well orange and blue work together. I used a warm Ultramarine for the bottle and cooler Prussian Blue for the cloth. The oranges were Cadmium Orange and Cadmium Yellow with a touch of Cadmium Red to indicate shape and form.

RED GERANIUMS

We all are attracted to this combination of red and green. The watering can sets a bluer green against a yellower red. The main complementaries used are Cadmium Red and Hooker's Green.

DRIED FLOWERS AND FRUIT

(LEFT)

This still life creates a strong reaction between the different yellows and violets. Lemon Yellow is used for the lemons, with Cadmium Yellow and Yellow Ochre for the flowers. A warmer violet is used for the mug with a bluer purple and ultramarine for the jug.

3 COLOUR PROPERTIES

How much simpler the use of colour would be if it could be stated that red is always warm and blue always cool. This is true when they are placed side by side for comparison. The problem is that the temperature relies on the relationships of all the colours in a painting and on the particular reds and blues you choose.

Generally speaking, warm colours tend to bring elements in a painting forwards and cool colours make them recede, so you might wonder how to handle red objects in the distance, for example, without destroying the three-dimensional effect you are trying to achieve. The answer rests in the colour mixture you are using.

On the colour wheel on page 23, you can see that each primary colour has a cool colour at one side and a warm one at the other. Cadmium Red is on the spectrum towards yellow and so is warmer than Alizarin Crimson, which is towards blue. Cadmium Yellow has orange in it and so is warmer than Lemon Yellow, which has green and a touch of blue in it. Prussian Blue is cool in comparison to Ultramarine, which has a touch of red.

The clearest purple comes from a mix of Ultramarine and Alizarin Crimson. If you mix Cadmium Red with either of the blues you will get a slightly off-purple bordering on grey. This is because Cadmium Red has that bit of yellow, so in fact you are mixing the three primaries. That type of colour, described as neutralized, is a subtle mix that is extremely useful in shadows.

While watercolour is known for its transparency, some pigments are less transparent than others. Opaque colours, relatively speaking, include the Cadmiums and Yellow Ochre, while Alizarin Crimson, Prussian Blue and Hooker's Green are among the transparent colours.

Some colours, notably Ultramarine, Cobalt Blue and Cerulean, produce a granulated wash when diluted because the pigment does not dissolve evenly in the water. This gives interesting texture that you can exploit in the right context. So not only do you need to consider the pigments for their colour, but also their different properties, which you can discover from the manufacturers' colour charts.

Rich, interesting darks can be achieved purely by mixing. At first, resist the urge to use blacks, which can make paintings muddy. Overworking and too many layers will also lead to that mud, so knowing the potential mixes to use will help enormously to make your paintings the way you truly want them.

Respect the differences between colours rather than trying to push them to do what they cannot. Practise the mixes systematically before you embark on a painting, but be open to interesting surprises.

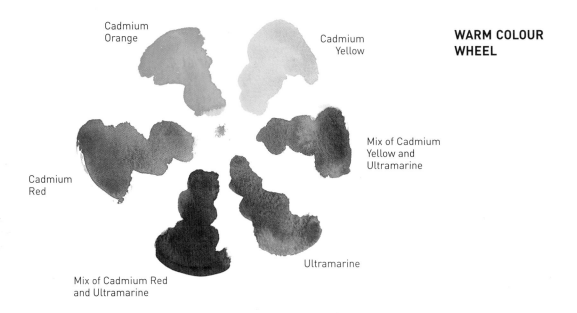

Cadmium
Orange

Cadmium
Yellow

**WARM COLOUR
WHEEL**

Cadmium
Red

Mix of Cadmium
Yellow and
Ultramarine

Mix of Cadmium Red
and Ultramarine

Ultramarine

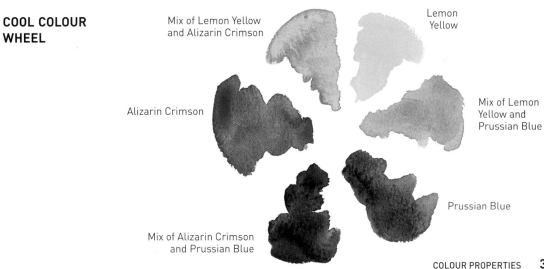

**COOL COLOUR
WHEEL**

Mix of Lemon Yellow
and Alizarin Crimson

Lemon
Yellow

Alizarin Crimson

Mix of Lemon
Yellow and
Prussian Blue

Mix of Alizarin Crimson
and Prussian Blue

Prussian Blue

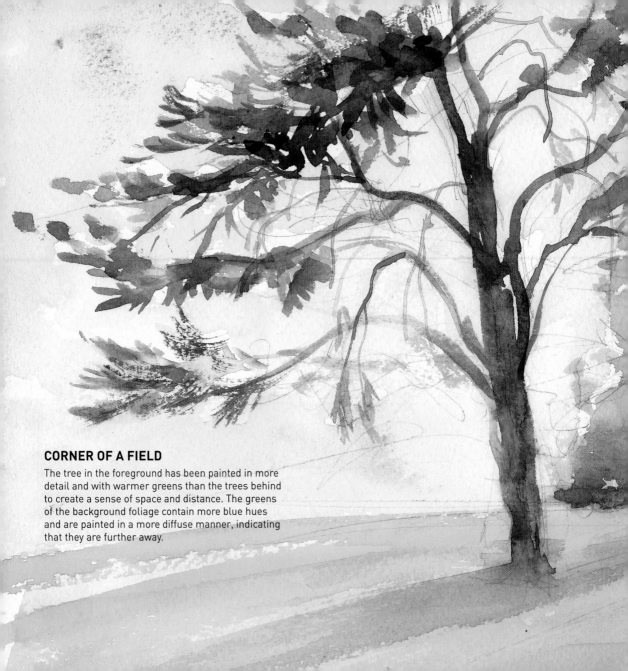

CORNER OF A FIELD

The tree in the foreground has been painted in more detail and with warmer greens than the trees behind to create a sense of space and distance. The greens of the background foliage contain more blue hues and are painted in a more diffuse manner, indicating that they are further away.

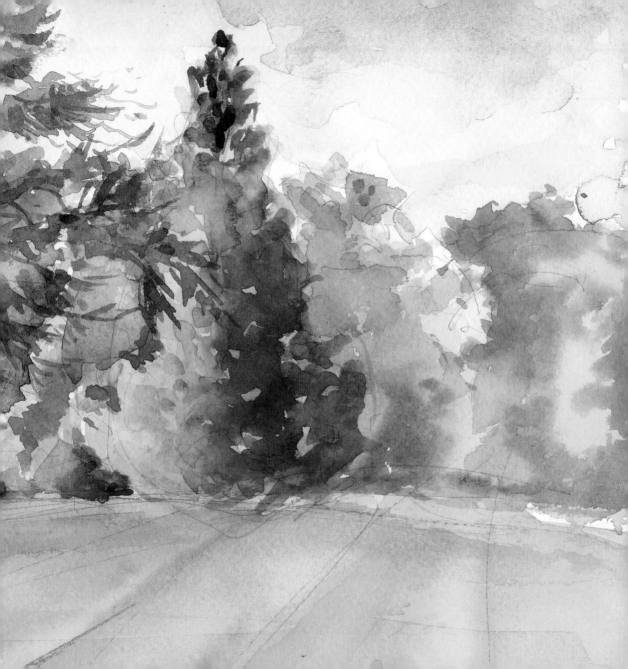

While both green and blue are considered cool, you can create a range of colour temperature to bring a three-dimensional effect to your paintings. To mix cool greens, use Lemon Yellow; for warm ones, Cadmium Yellow. It can be difficult to distinguish between cool and warm blues, but if you go back to the colour wheel you can see which are nearest the warm reds or cool greens.

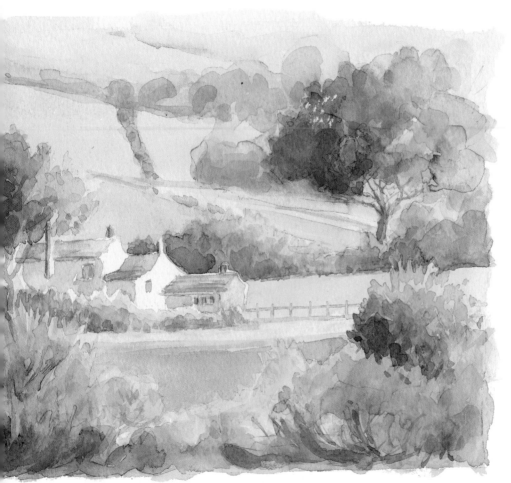

GREEN VALLEY
Vivid greens edged with yellow where the sunlight hits them help the foreground to advance. In the distance, the greens are bluer and cooler.

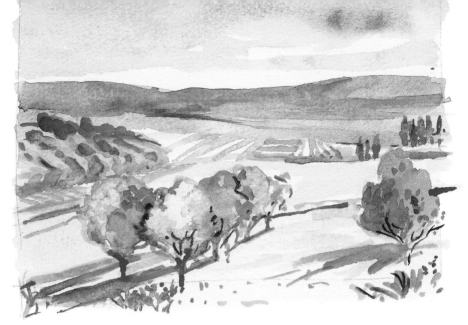

PLOUGHED FIELD AND TREES

STAGE 1

In order to create elements that seem closer to the viewer, I used a warm Ultramarine in the trees and darker areas. A 'cooler' Prussian Blue wash provides the underlying basis of the painting, creating a sky that is 'cooler' and therefore seems further away.

PLOUGHED FIELD AND TREES

STAGE 2

The same painting was overlaid with a cool Lemon Yellow wash to create a range of greens. A warm Cadmium Yellow was used in the foreground trees to intensify the effect of being nearer to the viewer.

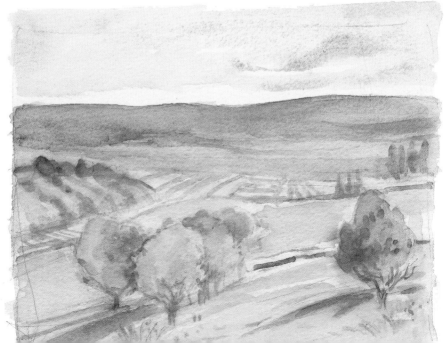

4 MIXING COLOUR

As you saw on pages 8–9, there are three different ways to mix the colours you want from your set of watercolours. Just as the colours you use should be an informed choice, so you need to make a decision about which method of mixing to use for its particular quality.

Palette mixing

Mixing two pigments together in a palette and then applying the mix to the paper enables you to mix a subtle range of colours as you can play with the proportions of each pigment before committing to paper. With practice, you will become skilled at quickly achieving the effect you want.

Overlaying

Allowing a colour to dry on the paper and then overlaying it with another one results in a brilliance of colour that is almost jewel-like. It is a particularly useful technique to use if you want to make an area stand out from the rest of the painting. You can also create a shadow by overlaying the same colour to make it appear darker.

Wet-into-wet

This method of allowing two or three wet colours to flood gently into one another on the paper to create an additional colour creates soft edges and gradations of tone that are ideal for skies, distant landscapes and other areas where you wish to suggest an out-of-focus effect. It is not easy to control, but the unpredictability of watercolour is one of its joys.

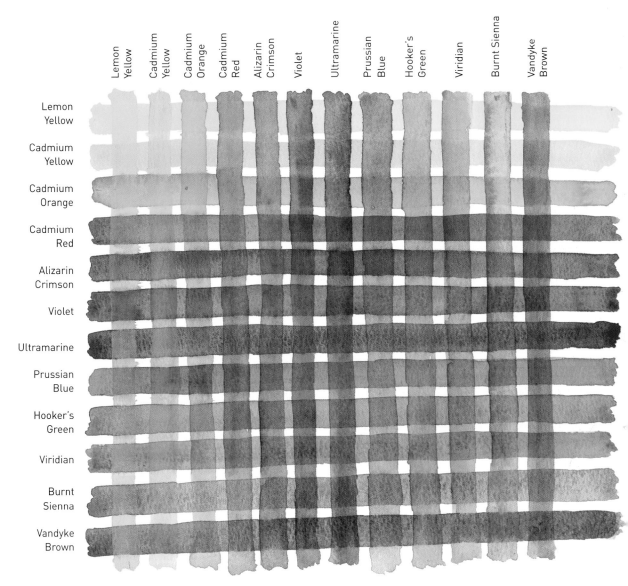

Palette mixes

LEMON YELLOW

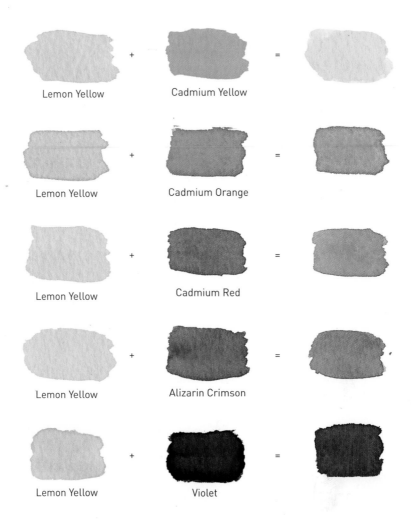

Lemon Yellow + Cadmium Yellow =

Lemon Yellow + Cadmium Orange =

Lemon Yellow + Cadmium Red =

Lemon Yellow + Alizarin Crimson =

Lemon Yellow + Violet =

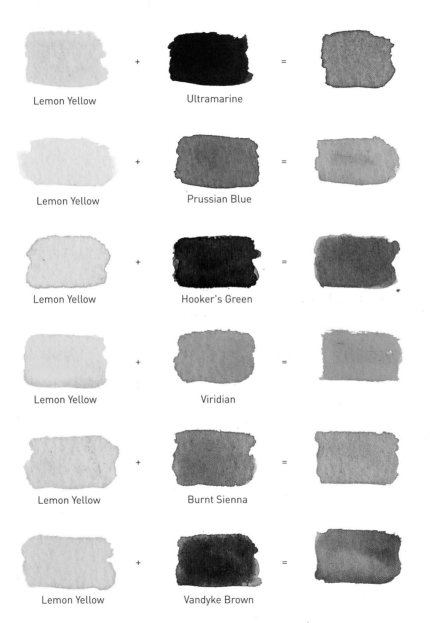

Lemon Yellow + Ultramarine =

Lemon Yellow + Prussian Blue =

Lemon Yellow + Hooker's Green =

Lemon Yellow + Viridian =

Lemon Yellow + Burnt Sienna =

Lemon Yellow + Vandyke Brown =

CADMIUM YELLOW

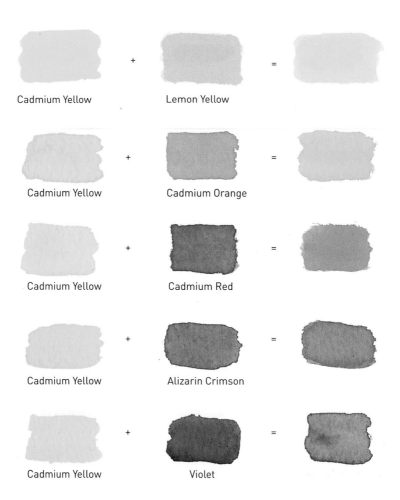

Cadmium Yellow + Lemon Yellow =

Cadmium Yellow + Cadmium Orange =

Cadmium Yellow + Cadmium Red =

Cadmium Yellow + Alizarin Crimson =

Cadmium Yellow + Violet =

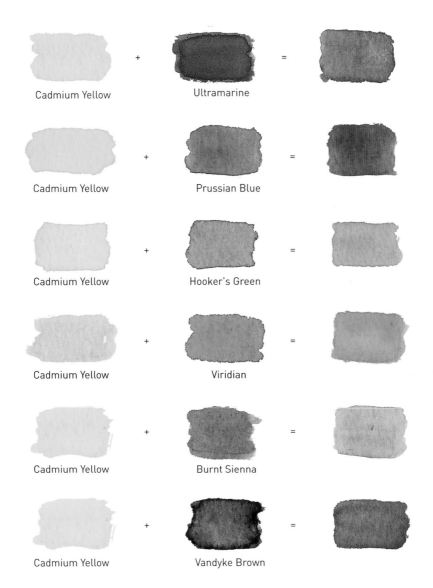

Cadmium Yellow + Ultramarine =

Cadmium Yellow + Prussian Blue =

Cadmium Yellow + Hooker's Green =

Cadmium Yellow + Viridian =

Cadmium Yellow + Burnt Sienna =

Cadmium Yellow + Vandyke Brown =

Palette mixing in practice

Cadmium Yellow mixed with a touch of Cadmium Red

Several layers of Cadmium Yellow on wet paper

Cadmium Yellow mixed with a touch of Cadmium Red

Cadmium Yellow mixed with Vandyke Brown

Touches of Cadmium Red on Cadmium Yellow on wet paper

SUMMER SIESTA

PALETTE USED

Cadmium Yellow
Cadmium Red
Violet
Ultramarine
Burnt Sienna
Vandyke Brown
Yellow Ochre
White

The different hues and shades of this painting were achieved by mixing Cadmium Yellow in a palette with a variety of different colours, including Cadmium Red, Yellow Ochre, Burnt Sienna and Vandyke Brown. For the bedspread, layers of Cadmium Yellow were applied, with mixes of Cadmium Yellow and Vandyke Brown applied in darker areas to create shadows. The back, feet and face of the figure are all composed of Cadmium Yellow and Cadmium Red palette mixes, the red emphasizing the contours of the body and turn of the head and cheek. The floor is an even mix of Cadmium Yellow and Burnt Sienna.

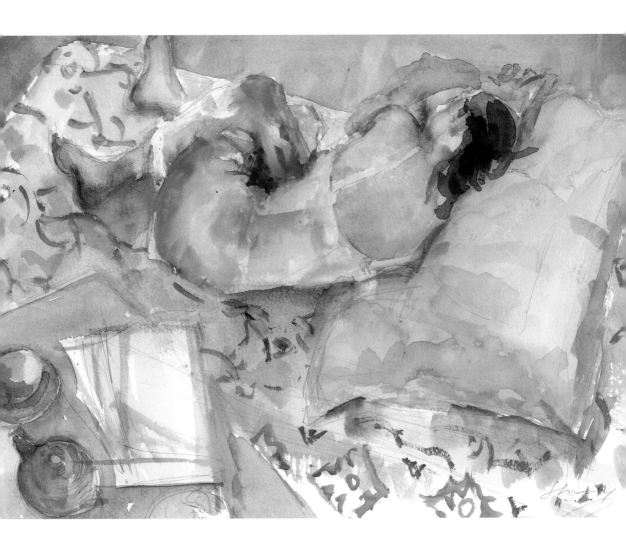

CADMIUM ORANGE

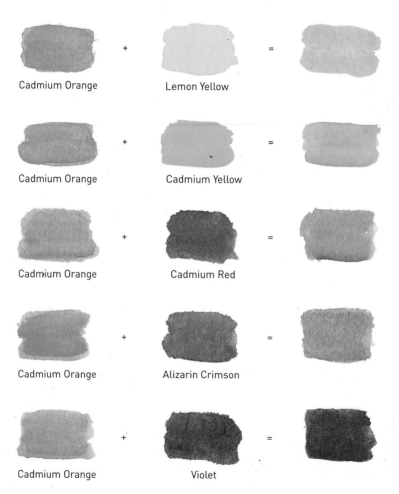

Cadmium Orange	+	Lemon Yellow	=
Cadmium Orange	+	Cadmium Yellow	=
Cadmium Orange	+	Cadmium Red	=
Cadmium Orange	+	Alizarin Crimson	=
Cadmium Orange	+	Violet	=

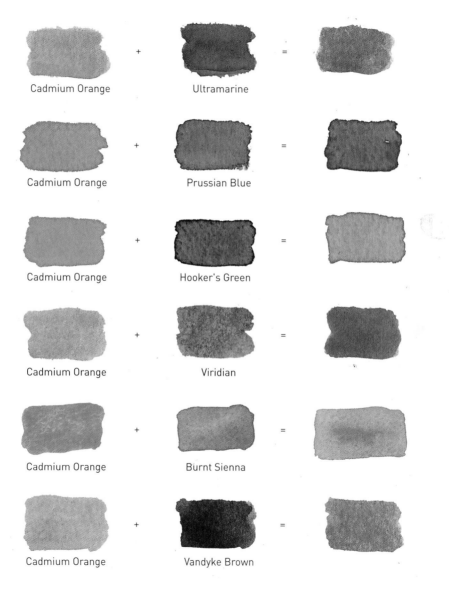

Cadmium Orange + Ultramarine =

Cadmium Orange + Prussian Blue =

Cadmium Orange + Hooker's Green =

Cadmium Orange + Viridian =

Cadmium Orange + Burnt Sienna =

Cadmium Orange + Vandyke Brown =

CADMIUM RED

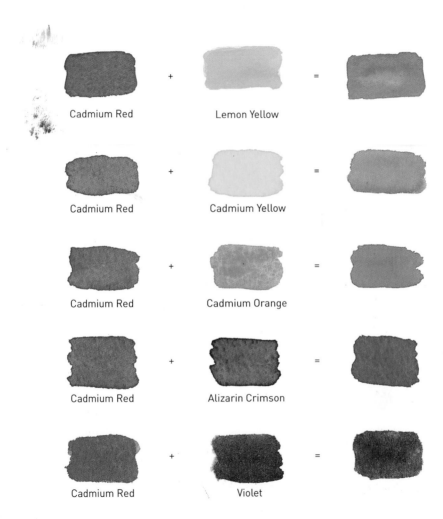

Cadmium Red	+ Lemon Yellow	=
Cadmium Red	+ Cadmium Yellow	=
Cadmium Red	+ Cadmium Orange	=
Cadmium Red	+ Alizarin Crimson	=
Cadmium Red	+ Violet	=

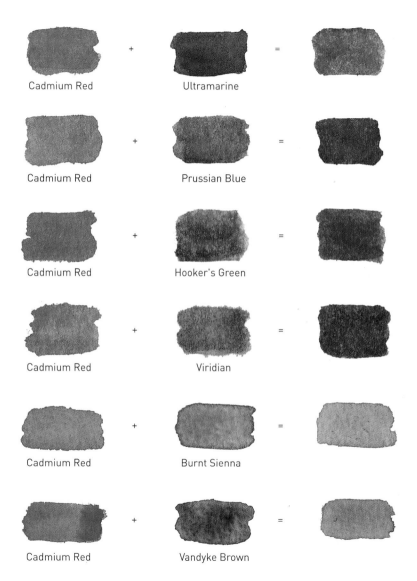

Cadmium Red	Ultramarine	
Cadmium Red	Prussian Blue	
Cadmium Red	Hooker's Green	
Cadmium Red	Viridian	
Cadmium Red	Burnt Sienna	
Cadmium Red	Vandyke Brown	

ALIZARIN CRIMSON

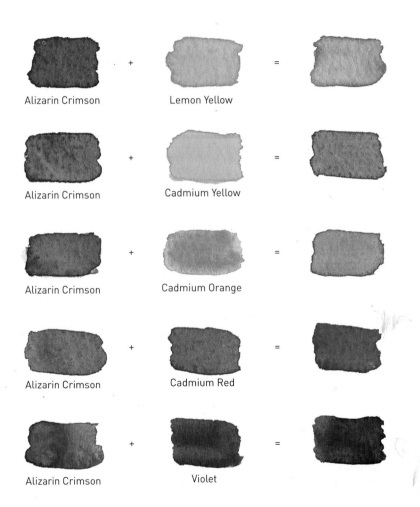

Alizarin Crimson + Lemon Yellow =

Alizarin Crimson + Cadmium Yellow =

Alizarin Crimson + Cadmium Orange =

Alizarin Crimson + Cadmium Red =

Alizarin Crimson + Violet =

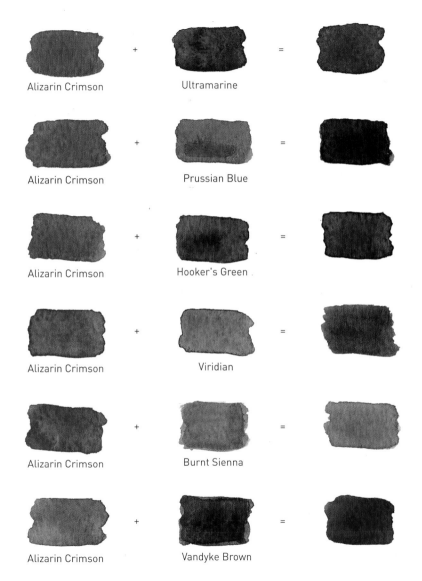

Alizarin Crimson + Ultramarine =

Alizarin Crimson + Prussian Blue =

Alizarin Crimson + Hooker's Green =

Alizarin Crimson + Viridian =

Alizarin Crimson + Burnt Sienna =

Alizarin Crimson + Vandyke Brown =

VIOLET

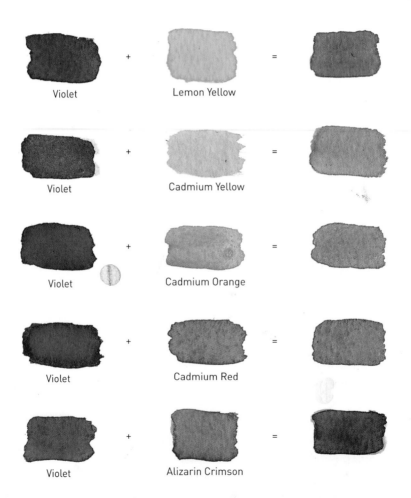

Violet	+ Lemon Yellow	=
Violet	+ Cadmium Yellow	=
Violet	+ Cadmium Orange	=
Violet	+ Cadmium Red	=
Violet	+ Alizarin Crimson	=

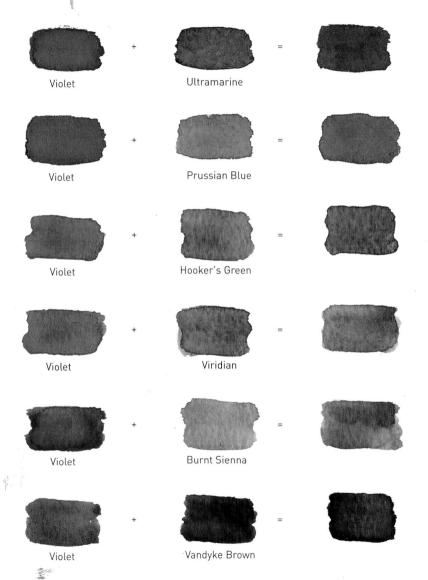

Violet	+	Ultramarine	=
Violet	+	Prussian Blue	=
Violet	+	Hooker's Green	=
Violet	+	Viridian	=
Violet	+	Burnt Sienna	=
Violet	+	Vandyke Brown	=

ULTRAMARINE

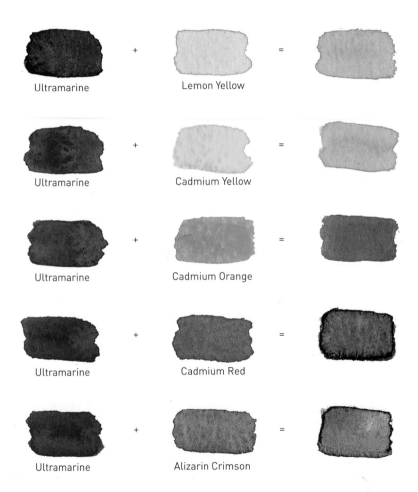

Ultramarine + Lemon Yellow =

Ultramarine + Cadmium Yellow =

Ultramarine + Cadmium Orange =

Ultramarine + Cadmium Red =

Ultramarine + Alizarin Crimson =

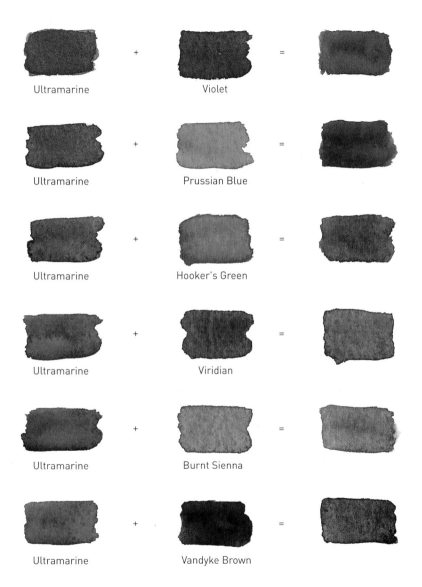

Ultramarine	+ Violet	=
Ultramarine	+ Prussian Blue	=
Ultramarine	+ Hooker's Green	=
Ultramarine	+ Viridian	=
Ultramarine	+ Burnt Sienna	=
Ultramarine	+ Vandyke Brown	=

PRUSSIAN BLUE

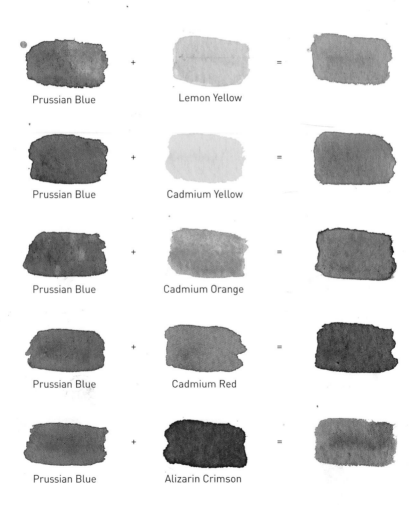

Prussian Blue + Lemon Yellow =

Prussian Blue + Cadmium Yellow =

Prussian Blue + Cadmium Orange =

Prussian Blue + Cadmium Red =

Prussian Blue + Alizarin Crimson =

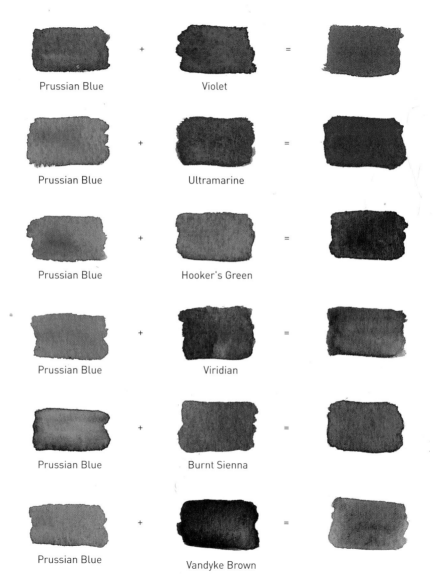

Prussian Blue + Violet =

Prussian Blue + Ultramarine =

Prussian Blue + Hooker's Green =

Prussian Blue + Viridian =

Prussian Blue + Burnt Sienna =

Prussian Blue + Vandyke Brown =

HOOKER'S GREEN

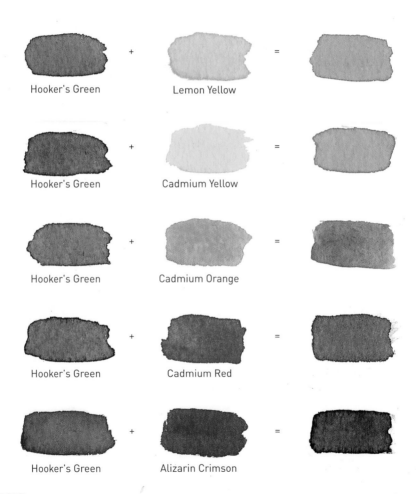

Hooker's Green + Lemon Yellow =

Hooker's Green + Cadmium Yellow =

Hooker's Green + Cadmium Orange =

Hooker's Green + Cadmium Red =

Hooker's Green + Alizarin Crimson =

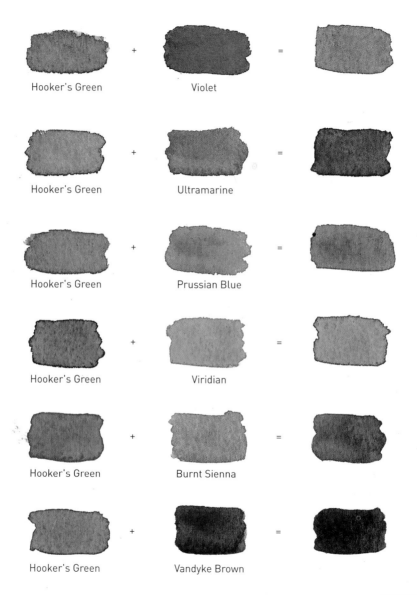

Hooker's Green + Violet =

Hooker's Green + Ultramarine =

Hooker's Green + Prussian Blue =

Hooker's Green + Viridian =

Hooker's Green + Burnt Sienna =

Hooker's Green + Vandyke Brown =

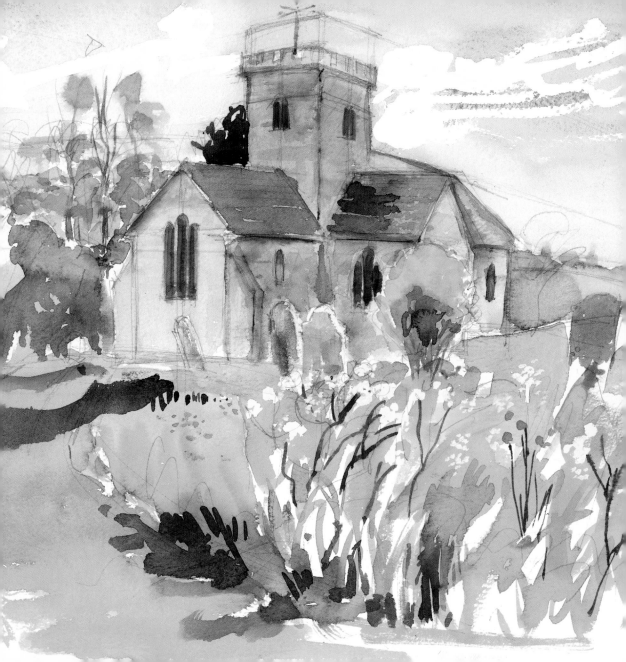

Palette mixing in practice

**VILLAGE
CHURCH
AND FIELD**

PALETTE USED
Lemon Yellow
Prussian Blue
Hooker's Green
Burnt Sienna
Yellow Ochre
Payne's Grey

Payne's Grey mixed
with Yellow Ochre

Hooker's Green mixed with
a touch of Lemon Yellow

Yellow Ochre mixed
with Burnt Sienna

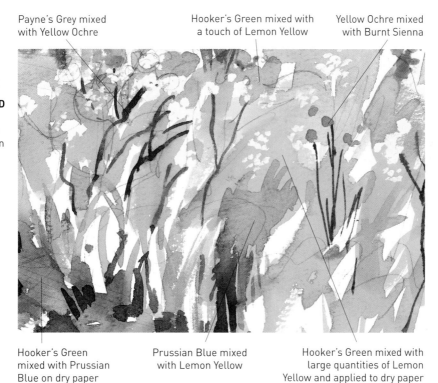

Hooker's Green
mixed with Prussian
Blue on dry paper

Prussian Blue mixed
with Lemon Yellow

Hooker's Green mixed with
large quantities of Lemon
Yellow and applied to dry paper

Palette mixing is a particularly useful technique for ensuring that the correct mix is achieved before applying it to the paper. In this painting, Hooker's Green is mixed with Prussian Blue, Payne's Grey and Yellow Ochre to create a sense of space and distance. A mix of Hooker's Green and Prussian Blue is used for the trees in the background to push them into the distance while Hooker's Green is mixed with Yellow Ochre and Lemon Yellow to bring the grasses in the foreground closer to the viewer. Hooker's Green and Payne's Grey also make an intense and interesting colour mix. Payne's Grey is a very blue grey so can be used effectively with warm yellowy greens, as demonstrated in the walls and tower of the church.

VIRIDIAN

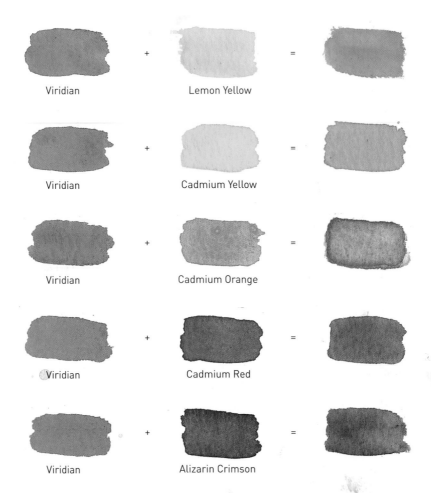

Viridian + Lemon Yellow =

Viridian + Cadmium Yellow =

Viridian + Cadmium Orange =

Viridian + Cadmium Red =

Viridian + Alizarin Crimson =

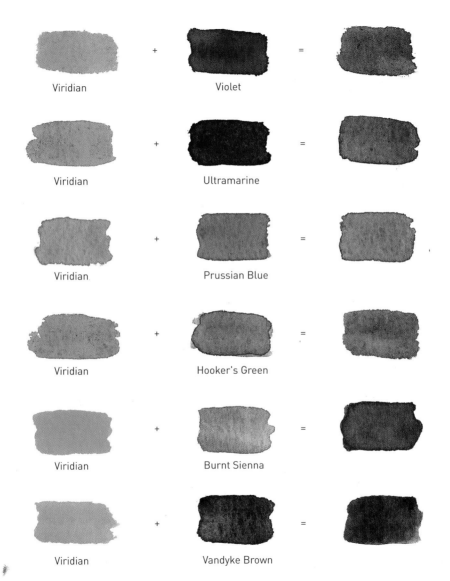

Viridian + Violet =

Viridian + Ultramarine =

Viridian + Prussian Blue =

Viridian + Hooker's Green =

Viridian + Burnt Sienna =

Viridian + Vandyke Brown =

BURNT SIENNA

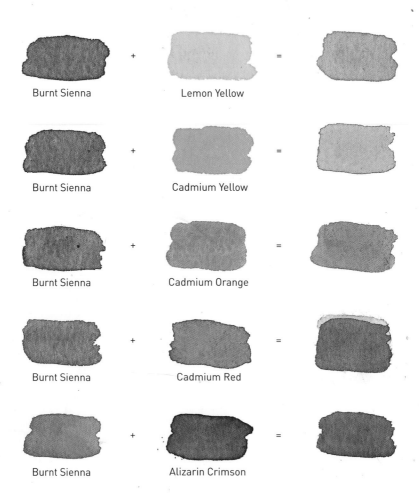

Burnt Sienna	+ Lemon Yellow	=
Burnt Sienna	+ Cadmium Yellow	=
Burnt Sienna	+ Cadmium Orange	=
Burnt Sienna	+ Cadmium Red	=
Burnt Sienna	+ Alizarin Crimson	=

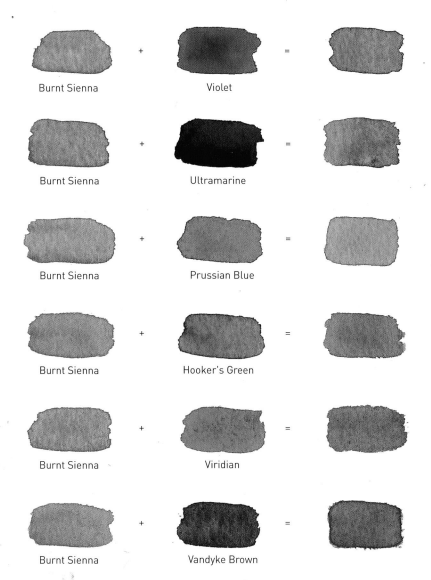

Burnt Sienna + Violet =

Burnt Sienna + Ultramarine =

Burnt Sienna + Prussian Blue =

Burnt Sienna + Hooker's Green =

Burnt Sienna + Viridian =

Burnt Sienna + Vandyke Brown =

VANDYKE BROWN

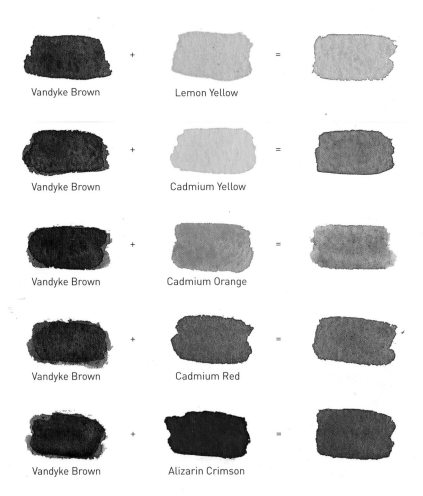

Vandyke Brown + Lemon Yellow =

Vandyke Brown + Cadmium Yellow =

Vandyke Brown + Cadmium Orange =

Vandyke Brown + Cadmium Red =

Vandyke Brown + Alizarin Crimson =

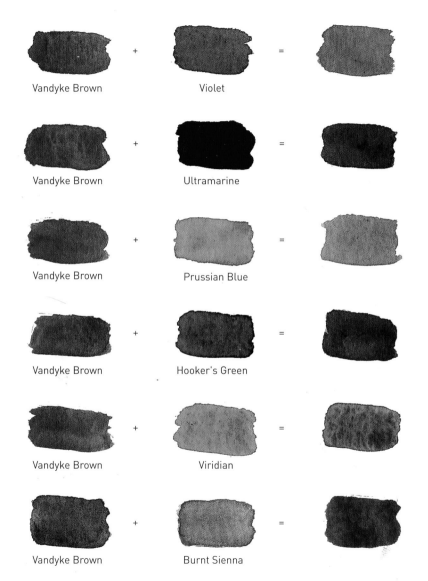

Vandyke Brown + Violet =

Vandyke Brown + Ultramarine =

Vandyke Brown + Prussian Blue =

Vandyke Brown + Hooker's Green =

Vandyke Brown + Viridian =

Vandyke Brown + Burnt Sienna =

PERMANENT ROSE

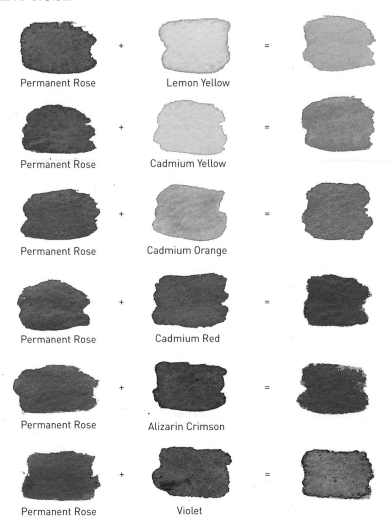

Permanent Rose	+ Lemon Yellow	=
Permanent Rose	+ Cadmium Yellow	=
Permanent Rose	+ Cadmium Orange	=
Permanent Rose	+ Cadmium Red	=
Permanent Rose	+ Alizarin Crimson	=
Permanent Rose	+ Violet	=

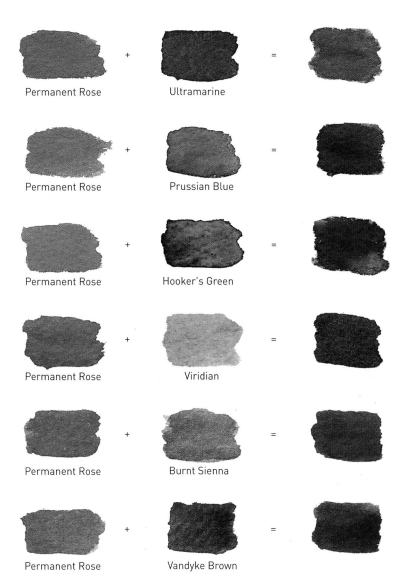

Permanent Rose + Ultramarine =

Permanent Rose + Prussian Blue =

Permanent Rose + Hooker's Green =

Permanent Rose + Viridian =

Permanent Rose + Burnt Sienna =

Permanent Rose + Vandyke Brown =

YELLOW OCHRE

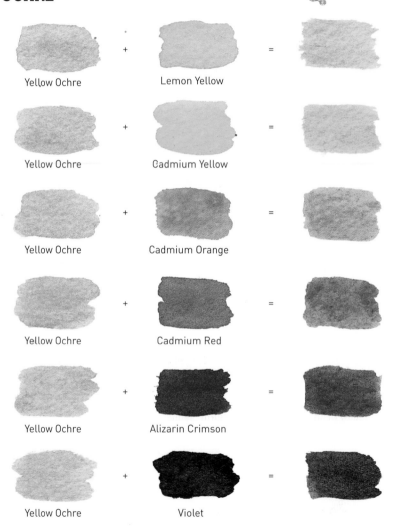

Yellow Ochre + Lemon Yellow =

Yellow Ochre + Cadmium Yellow =

Yellow Ochre + Cadmium Orange =

Yellow Ochre + Cadmium Red =

Yellow Ochre + Alizarin Crimson =

Yellow Ochre + Violet =

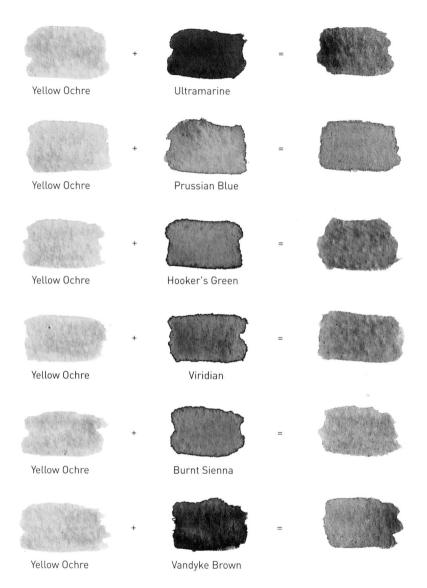

Yellow Ochre	+ Ultramarine	=
Yellow Ochre	+ Prussian Blue	=
Yellow Ochre	+ Hooker's Green	=
Yellow Ochre	+ Viridian	=
Yellow Ochre	+ Burnt Sienna	=
Yellow Ochre	+ Vandyke Brown	=

PAYNE'S GREY

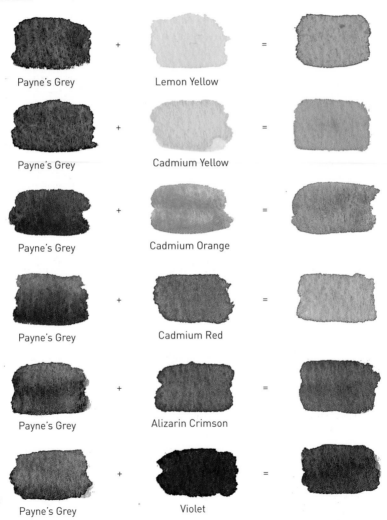

Payne's Grey	+	Lemon Yellow	=	
Payne's Grey	+	Cadmium Yellow	=	
Payne's Grey	+	Cadmium Orange	=	
Payne's Grey	+	Cadmium Red	=	
Payne's Grey	+	Alizarin Crimson	=	
Payne's Grey	+	Violet	=	

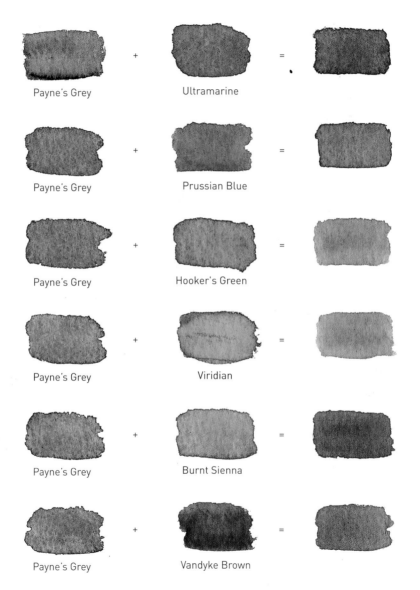

Payne's Grey	+	Ultramarine	=
Payne's Grey	+	Prussian Blue	=
Payne's Grey	+	Hooker's Green	=
Payne's Grey	+	Viridian	=
Payne's Grey	+	Burnt Sienna	=
Payne's Grey	+	Vandyke Brown	=

Overlaying

LEMON YELLOW

Lemon Yellow + Cadmium Yellow

Lemon Yellow + Cadmium Orange

Lemon Yellow + Cadmium Red

Lemon Yellow + Alizarin Crimson

Lemon Yellow + Violet

Lemon Yellow + Ultramarine

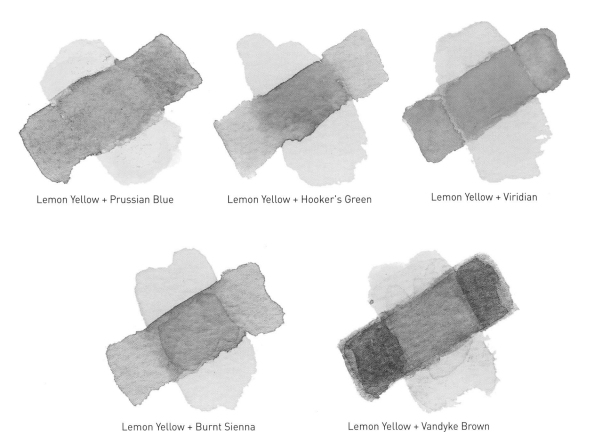

Lemon Yellow + Prussian Blue

Lemon Yellow + Hooker's Green

Lemon Yellow + Viridian

Lemon Yellow + Burnt Sienna

Lemon Yellow + Vandyke Brown

CADMIUM YELLOW

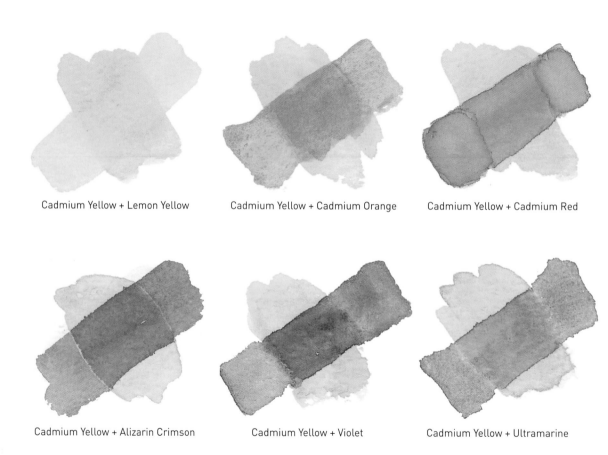

Cadmium Yellow + Lemon Yellow

Cadmium Yellow + Cadmium Orange

Cadmium Yellow + Cadmium Red

Cadmium Yellow + Alizarin Crimson

Cadmium Yellow + Violet

Cadmium Yellow + Ultramarine

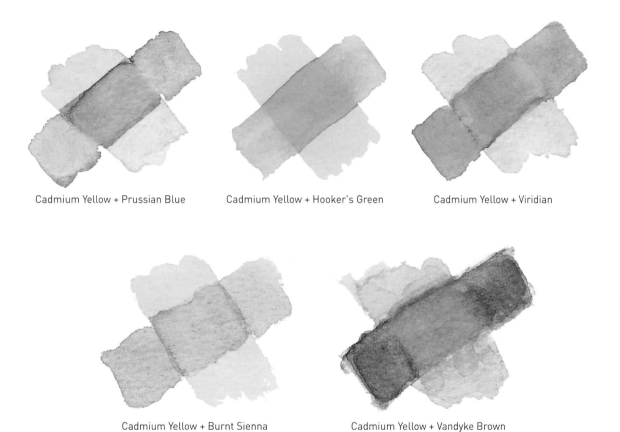

Cadmium Yellow + Prussian Blue

Cadmium Yellow + Hooker's Green

Cadmium Yellow + Viridian

Cadmium Yellow + Burnt Sienna

Cadmium Yellow + Vandyke Brown

CADMIUM ORANGE

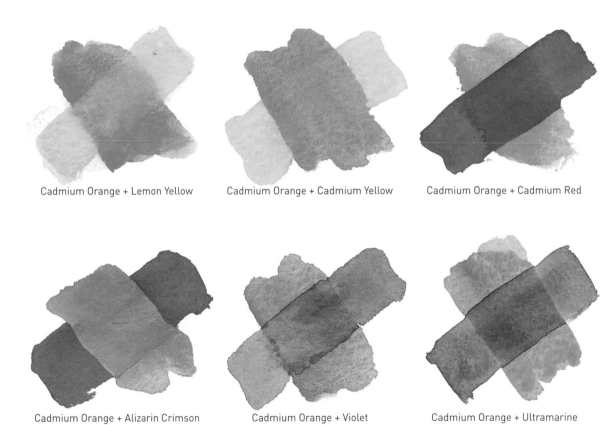

Cadmium Orange + Lemon Yellow

Cadmium Orange + Cadmium Yellow

Cadmium Orange + Cadmium Red

Cadmium Orange + Alizarin Crimson

Cadmium Orange + Violet

Cadmium Orange + Ultramarine

Cadmium Orange + Prussian Blue

Cadmium Orange + Hooker's Green

Cadmium Orange + Viridian

Cadmium Orange + Burnt Sienna

Cadmium Orange + Vandyke Brown

CADMIUM RED

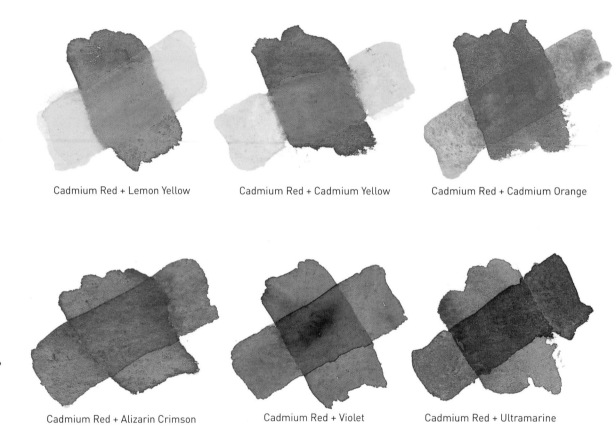

Cadmium Red + Lemon Yellow

Cadmium Red + Cadmium Yellow

Cadmium Red + Cadmium Orange

Cadmium Red + Alizarin Crimson

Cadmium Red + Violet

Cadmium Red + Ultramarine

Cadmium Red + Prussian Blue Cadmium Red + Hooker's Green Cadmium Red + Viridian

Cadmium Red + Burnt Sienna Cadmium Red + Vandyke Brown

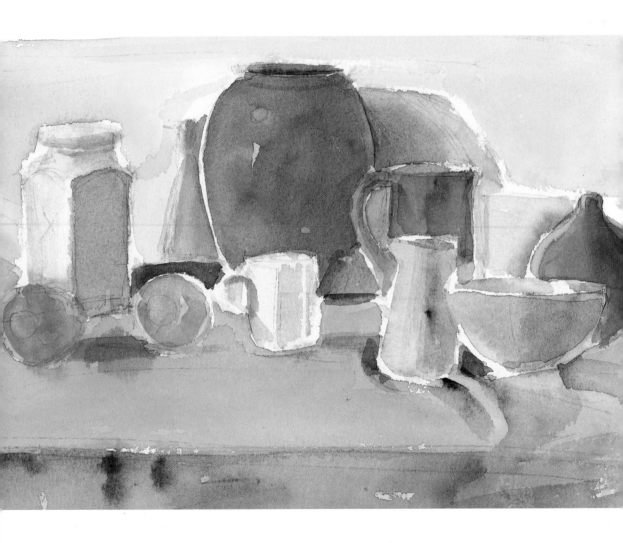

Overlaying in practice

**CERAMICS
ON A TABLE**

PALETTE USED
Cadmium Yellow
Cadmium Orange
Cadmium Red
Alizarin Crimson
Hooker's Green
Payne's Grey
Black

Hooker's Green overlaid
with many glazes of
Cadmium Red

Cadmium Red
overlaid with Black

Cadmium Yellow
overlaid with
Cadmium Orange

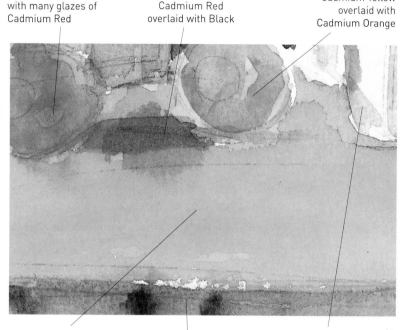

Cadmium Red and Alizarin
Crimson mix with overlaid
glaze of Cadmium Yellow

Cadmium Red and
Alizarin Crimson mix,
overlaid with Payne's Grey

Payne's Grey mixed with
diluted Alizarin Crimson and
overlaid with Cadmium Yellow

Overlaying is a wonderful technique for working with light and shadows – allowing one colour to dry before overlaying with another creates beautiful colour mixes that are full of depth. In this painting, areas of Cadmium Red have been overlaid with another colour and vice versa, creating simple, bold areas of changing colour. Although a still life, there is a sense of movement between the objects. The shadows on the fruit are built up to indicate shape and areas of overlaid paint leave the colours peeking through as if the light has fallen on the objects. A Cadmium Red and Alizarin Crimson mix has been overlaid with Cadmium Yellow to depict the cloth and create a sense of light passing across the table.

ALIZARIN CRIMSON

Alizarin Crimson + Lemon Yellow

Alizarin Crimson + Cadmium Yellow

Alizarin Crimson + Cadmium Orange

Alizarin Crimson + Cadmium Red

Alizarin Crimson + Violet

Alizarin Crimson + Ultramarine

Alizarin Crimson + Prussian Blue

Alizarin Crimson + Hooker's Green

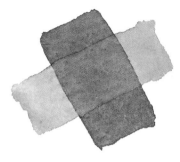

Alizarin Crimson + Viridian

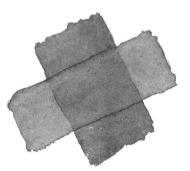

Alizarin Crimson + Burnt Sienna

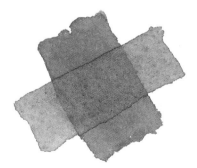

Alizarin Crimson + Vandyke Brown

VIOLET

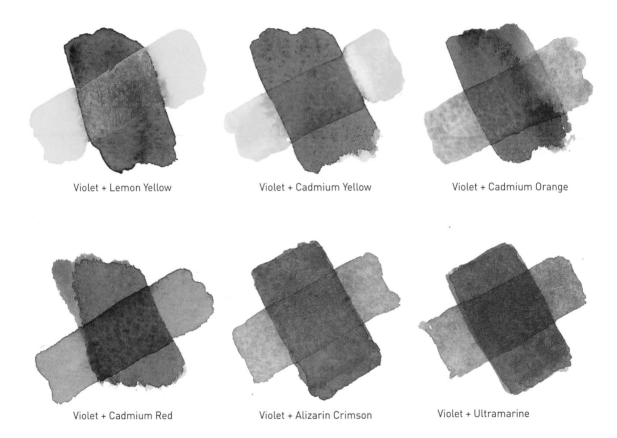

Violet + Lemon Yellow

Violet + Cadmium Yellow

Violet + Cadmium Orange

Violet + Cadmium Red

Violet + Alizarin Crimson

Violet + Ultramarine

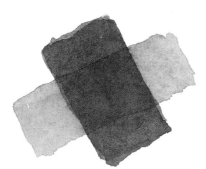

Violet + Prussian Blue

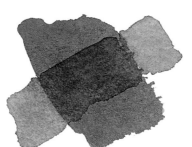

Violet + Hooker's Green

Violet + Viridian

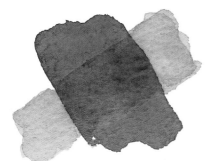

Violet + Burnt Sienna

Violet + Vandyke Brown

ULTRAMARINE

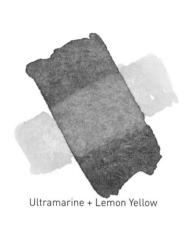

Ultramarine + Lemon Yellow

Ultramarine + Cadmium Yellow

Ultramarine + Cadmium Orange

Ultramarine + Cadmium Red

Ultramarine + Alizarin Crimson

Ultramarine + Violet

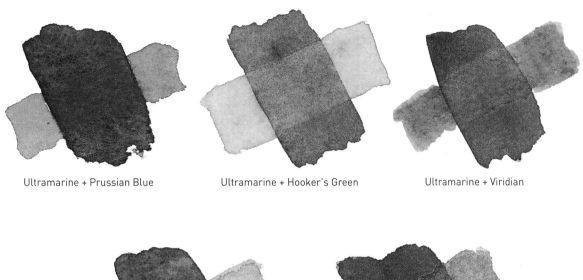

Ultramarine + Prussian Blue

Ultramarine + Hooker's Green

Ultramarine + Viridian

Ultramarine + Burnt Sienna

Ultramarine + Vandyke Brown

PRUSSIAN BLUE

Prussian Blue + Lemon Yellow

Prussian Blue + Cadmium Yellow

Prussian Blue + Cadmium Orange

Prussian Blue + Cadmium Red

Prussian Blue + Alizarin Crimson

Prussian Blue + Violet

Prussian Blue + Ultramarine

Prussian Blue + Hooker's Green

Prussian Blue + Viridian

Prussian Blue + Burnt Sienna

Prussian Blue + Vandyke Brown

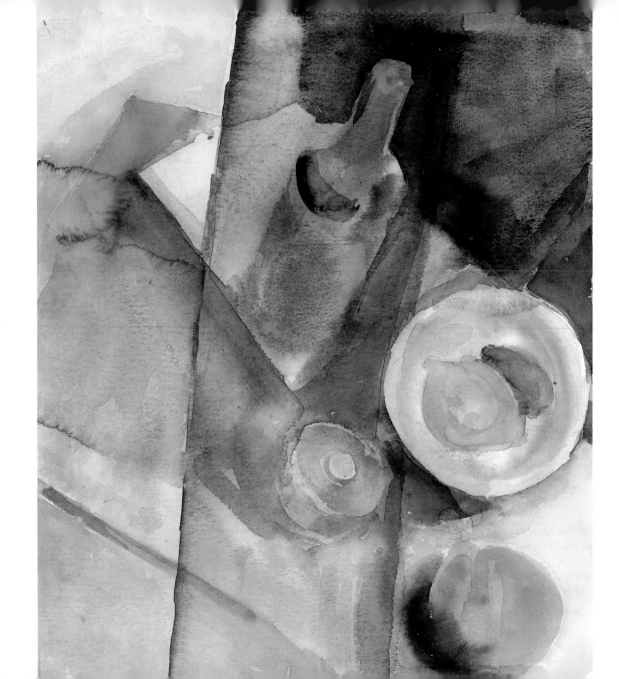

Overlaying in practice

Diluted glaze of Alizarin Crimson with overlaid glazes of Ultramarine

Hooker's Green with overlaid glazes of Prussian Blue

Alizarin Crimson with overlaid glaze of Prussian Blue

Diluted glaze of Yellow Ochre with overlaid glaze of Cadmium Red

SHADOWED STILL LIFE

PALETTE USED

Lemon Yellow
Cadmium Red
Alizarin Crimson
Ultramarine
Prussian Blue
Hooker's Green
Yellow Ochre
Black

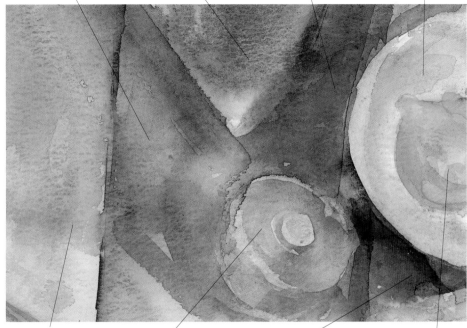

Prussian Blue with overlaid glazes of Ultramarine

Diluted glaze of Yellow Ochre overlaid with a mix of Cadmium Red and Lemon Yellow

Prussian Blue and a touch of Alizarin Crimson with overlaid glaze of Black

Lemon Yellow with overlaid glaze of Prussian Blue

I wanted to paint a still life from an unusual viewpoint. By overlaying one glaze of colour over another, the representational aspects of this painting are skewed to create a painting that is more than just a list of objects. Some of the objects apear to float away while other parts emerge more distinctly –

again, the areas of depth and shadow have been achieved by using overlaying techniques. Prussian Blue is a very intense colour and tends to stain the paper, so I used the other colours equally intensely by using a lot of paint and plenty of water to make strong, flowing colours.

HOOKER'S GREEN

Hooker's Green + Lemon Yellow

Hooker's Green + Cadmium Yellow

Hooker's Green + Cadmium Orange

Hooker's Green + Cadmium Red

Hooker's Green + Alizarin Crimson

Hooker's Green + Violet

Hooker's Green + Ultramarine

Hooker's Green + Prussian Blue

Hooker's Green + Viridian

Hooker's Green + Burnt Sienna

Hooker's Green + Vandyke Brown

VIRIDIAN

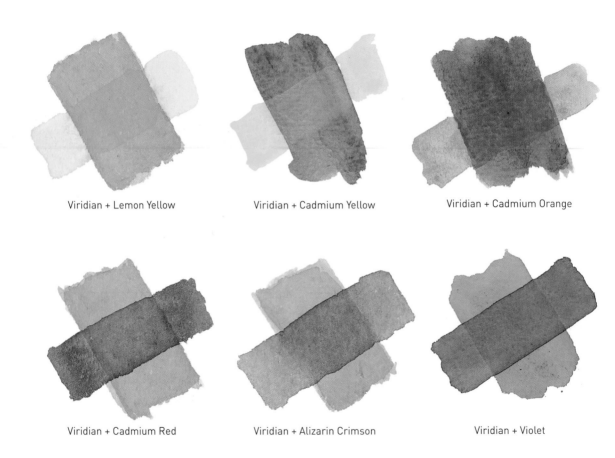

Viridian + Lemon Yellow

Viridian + Cadmium Yellow

Viridian + Cadmium Orange

Viridian + Cadmium Red

Viridian + Alizarin Crimson

Viridian + Violet

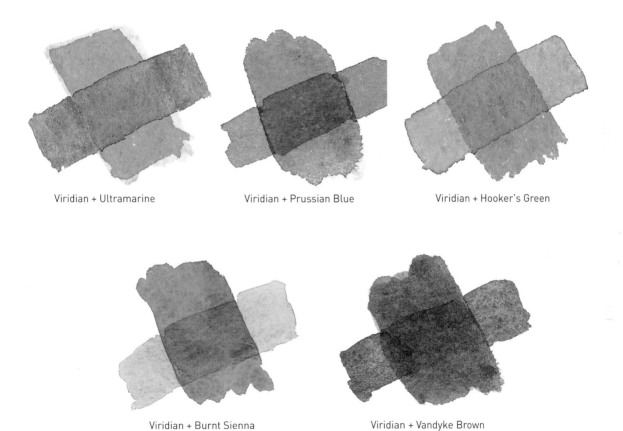

Viridian + Ultramarine

Viridian + Prussian Blue

Viridian + Hooker's Green

Viridian + Burnt Sienna

Viridian + Vandyke Brown

BURNT SIENNA

Burnt Sienna + Lemon Yellow

Burnt Sienna + Cadmium Yellow

Burnt Sienna + Cadmium Orange

Burnt Sienna + Cadmium Red

Burnt Sienna + Alizarin Crimson

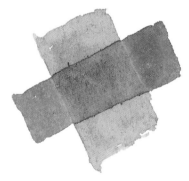

Burnt Sienna + Violet

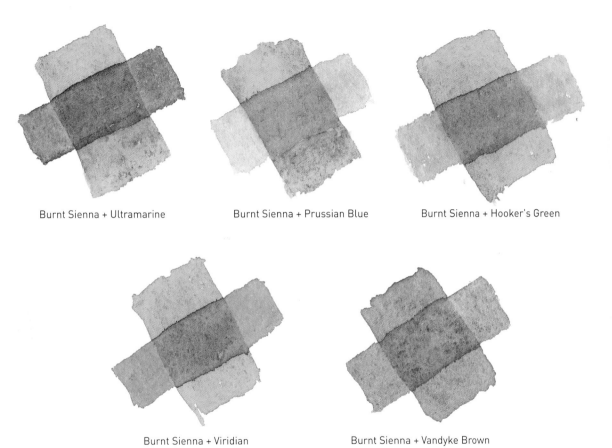

Burnt Sienna + Ultramarine

Burnt Sienna + Prussian Blue

Burnt Sienna + Hooker's Green

Burnt Sienna + Viridian

Burnt Sienna + Vandyke Brown

VANDYKE BROWN

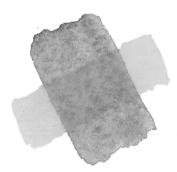

Vandyke Brown + Lemon Yellow

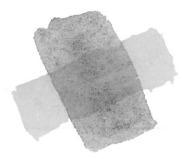

Vandyke Brown + Cadmium Yellow

Vandyke Brown + Cadmium Orange

Vandyke Brown + Cadmium Red

Vandyke Brown + Alizarin Crimson

Vandyke Brown + Violet

Vandyke Brown + Ultramarine

Vandyke Brown + Prussian Blue

Vandyke Brown + Hooker's Green

Vandyke Brown + Viridian

Vandyke Brown + Burnt Sienna

PERMANENT ROSE

Permanent Rose + Lemon Yellow

Permanent Rose + Cadmium Yellow

Permanent Rose + Cadmium Orange

Permanent Rose + Cadmium Red

Permanent Rose + Alizarin Crimson

Permanent Rose + Violet

Permanent Rose + Ultramarine

Permanent Rose + Prussian Blue

Permanent Rose + Hooker's Green

Permanent Rose + Viridian

Permanent Rose + Burnt Sienna

Permanent Rose + Vandyke Brown

YELLOW OCHRE

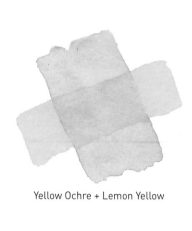

Yellow Ochre + Lemon Yellow

Yellow Ochre + Cadmium Yellow

Yellow Ochre + Cadmium Orange

Yellow Ochre + Cadmium Red

Yellow Ochre + Alizarin Crimson

Yellow Ochre + Violet

Yellow Ochre + Ultramarine

Yellow Ochre + Prussian Blue

Yellow Ochre + Hooker's Green

Yellow Ochre + Viridian

Yellow Ochre + Burnt Sienna

Yellow Ochre + Vandyke Brown

PAYNE'S GREY

Payne's Grey + Lemon Yellow

Payne's Grey + Cadmium Yellow

Payne's Grey + Cadmium Orange

Payne's Grey + Cadmium Red

Payne's Grey + Alizarin Crimson

Payne's Grey + Violet

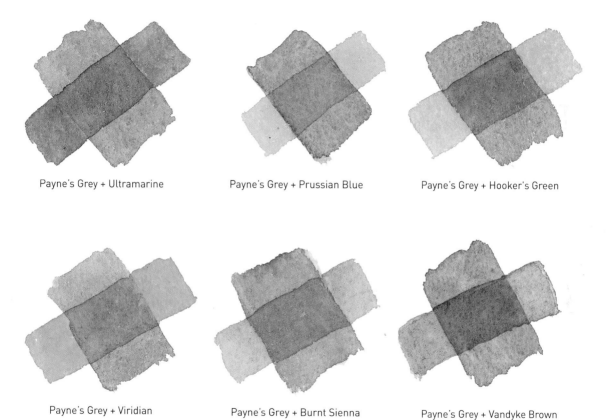

Payne's Grey + Ultramarine

Payne's Grey + Prussian Blue

Payne's Grey + Hooker's Green

Payne's Grey + Viridian

Payne's Grey + Burnt Sienna

Payne's Grey + Vandyke Brown

Wet-into-wet

LEMON YELLOW

Lemon Yellow + Cadmium Yellow

Lemon Yellow + Cadmium Orange

Lemon Yellow + Cadmium Red

Lemon Yellow + Alizarin Crimson

Lemon Yellow + Violet

Lemon Yellow + Ultramarine

Lemon Yellow + Prussian Blue

Lemon Yellow + Hooker's Green

Lemon Yellow + Viridian

Lemon Yellow + Burnt Sienna

Lemon Yellow + Vandyke Brown

Wet-into-wet in practice

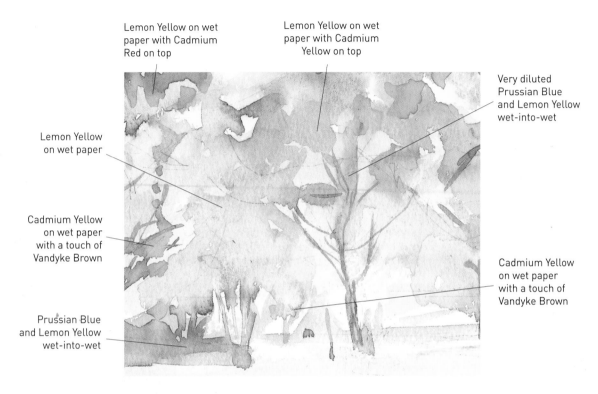

Lemon Yellow on wet paper with Cadmium Red on top

Lemon Yellow on wet paper with Cadmium Yellow on top

Very diluted Prussian Blue and Lemon Yellow wet-into-wet

Lemon Yellow on wet paper

Cadmium Yellow on wet paper with a touch of Vandyke Brown

Cadmium Yellow on wet paper with a touch of Vandyke Brown

Prussian Blue and Lemon Yellow wet-into-wet

Wet-into-wet techniques are perfect for creating foliage and areas of simple colour, such as the grass in the foreground of this painting. The merging of colours, either partially or completely, adds interest in areas where details are unnecessary. Clusters of leaves in golden, autumnal colours such as Lemon Yellow, Cadmium Yellow and Cadmium Red, were painted on to wet paper but with strong, undiluted colours so that the leaf shapes are retained but softened by the technique. Changing the direction and shape of brushmarks is vital, even when the paper is wet. The wet-into-wet principles can be used for a variety of effects, from suggesting undergrowth at the front of a painting to distant swathes of grass. Even the trunks are painted with dry paint on to wet colour.

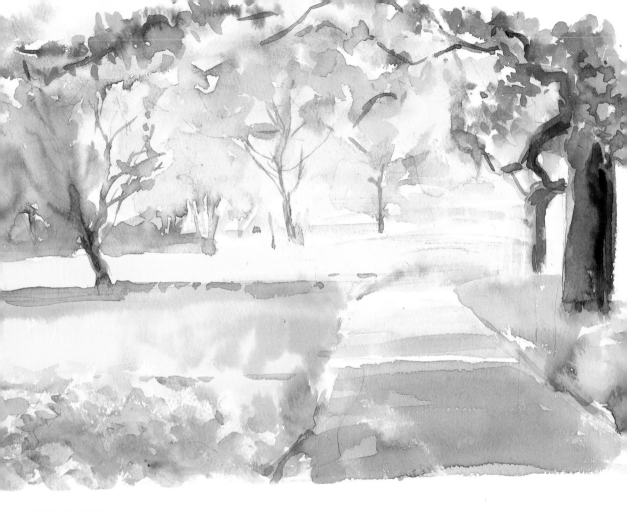

AUTUMN PATH

PALETTE USED
Lemon Yellow
Cadmium Yellow
Cadmium Red
Prussian Blue
Hooker's Green
Burnt Sienna
Vandyke Brown

CADMIUM YELLOW

Cadmium Yellow + Lemon Yellow

Cadmium Yellow + Cadmium Orange

Cadmium Yellow + Cadmium Red

Cadmium Yellow + Alizarin Crimson

Cadmium Yellow + Violet

Cadmium Yellow + Ultramarine

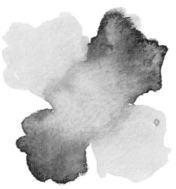

Cadmium Yellow + Prussian Blue

Cadmium Yellow + Hooker's Green

Cadmium Yellow + Viridian

Cadmium Yellow + Burnt Sienna

Cadmium Yellow + Vandyke Brown

CADMIUM ORANGE

Cadmium Orange + Lemon Yellow

Cadmium Orange + Cadmium Yellow

Cadmium Orange + Cadmium Red

Cadmium Orange + Alizarin Crimson

Cadmium Orange + Violet

Cadmium Orange + Ultramarine

Cadmium Orange + Prussian Blue

Cadmium Orange + Hooker's Green

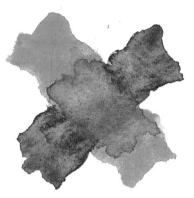

Cadmium Orange + Viridian

Cadmium Orange + Burnt Sienna

Cadmium Orange + Vandyke Brown

CADMIUM RED

Cadmium Red + Lemon Yellow

Cadmium Red + Cadmium Yellow

Cadmium Red + Cadmium Orange

Cadmium Red + Alizarin Crimson

Cadmium Red + Violet

Cadmium Red + Ultramarine

Cadmium Red + Prussian Blue

Cadmium Red + Hooker's Green

Cadmium Red + Viridian

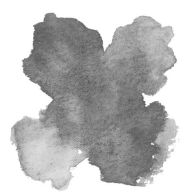

Cadmium Red + Burnt Sienna

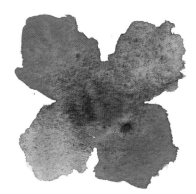

Cadmium Red + Vandyke Brown

ALIZARIN CRIMSON

Alizarin Crimson + Lemon Yellow

Alizarin Crimson + Cadmium Yellow

Alizarin Crimson + Cadmium Orange

Alizarin Crimson + Cadmium Red

Alizarin Crimson + Violet

Alizarin Crimson + Ultramarine

Alizarin Crimson + Prussian Blue

Alizarin Crimson + Hooker's Green

Alizarin Crimson + Viridian

Alizarin Crimson + Burnt Sienna

Alizarin Crimson + Vandyke Brown

VIOLET

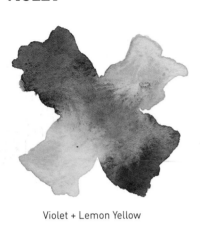

Violet + Lemon Yellow

Violet + Cadmium Yellow

Violet + Cadmium Orange

Violet + Cadmium Red

Violet + Alizarin Crimson

Violet + Ultramarine

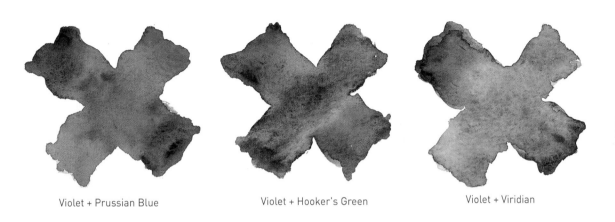

Violet + Prussian Blue

Violet + Hooker's Green

Violet + Viridian

Violet + Burnt Sienna

Violet + Vandyke Brown

ULTRAMARINE

Ultramarine + Lemon Yellow

Ultramarine + Cadmium Yellow

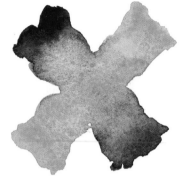

Ultramarine + Cadmium Orange

Ultramarine + Cadmium Red

Ultramarine + Alizarin Crimson

Ultramarine + Violet

Ultramarine + Prussian Blue

Ultramarine + Hooker's Green

Ultramarine + Viridian

Ultramarine + Burnt Sienna

Ultramarine + Vandyke Brown

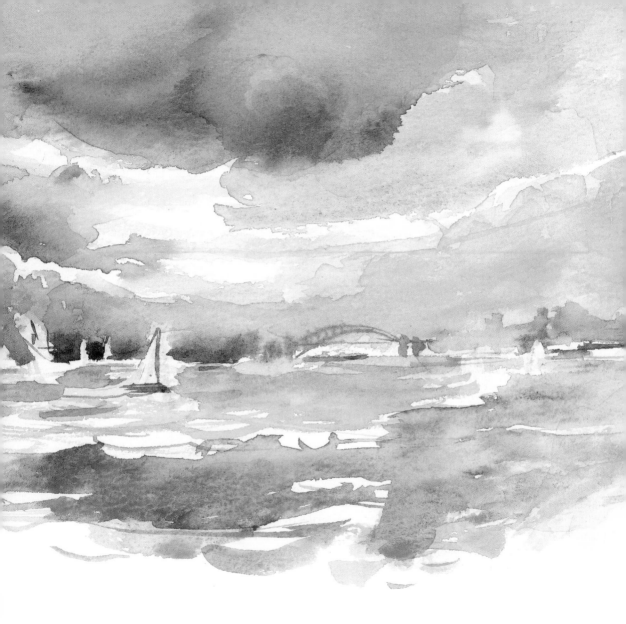

Wet-into-wet in practice

Payne's Grey and
Alizarin Crimson
mix on to wet paper

Alizarin Crimson into
damp Ultramarine
and Payne's Grey

Diluted Lemon Yellow
and Ultramarine on
to wet paper

**SYDNEY
HARBOUR**

PALETTE USED
Lemon Yellow
Alizarin Crimson
Ultramarine
Prussian Blue
Payne's Grey

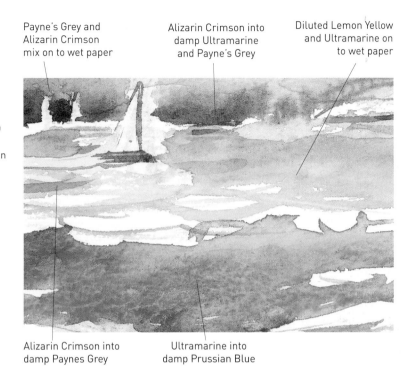

Alizarin Crimson into
damp Paynes Grey

Ultramarine into
damp Prussian Blue

An expanse of sky and water, as at this harbour, is perfect for exploring the fluidity and spontaneity of wet-into-wet techniques. Ultramarine creates great textural effects, which are often accidental. The pigment doesn't completely dissolve in water and it separates, causing granulation, which is particularly useful for painting the swirls and waves of water and movement in skies. Where the horizon meets the land I painted into very damp colour with slightly diluted paint, keeping greys to the left and leaving the paper white for sailing boats. The warmer colours to the right suggest buildings. The horizontal brushstrokes of the ocean echo waves but the brushstrokes in the sky are broader, utilizing large areas of wet colour where even more water was splashed into the blue to create a billowing effect.

PRUSSIAN BLUE

Prussian Blue + Lemon Yellow

Prussian Blue + Cadmium Yellow

Prussian Blue + Cadmium Orange

Prussian Blue + Cadmium Red

Prussian Blue + Alizarin Crimson

Prussian Blue + Violet

Prussian Blue + Ultramarine

Prussian Blue + Hooker's Green

Prussian Blue + Viridian

Prussian Blue + Burnt Sienna

Prussian Blue + Vandyke Brown

HOOKER'S GREEN

Hooker's Green + Lemon Yellow

Hooker's Green + Cadmium Yellow

Hooker's Green + Cadmium Orange

Hooker's Green + Cadmium Red

Hooker's Green + Alizarin Crimson

Hooker's Green + Violet

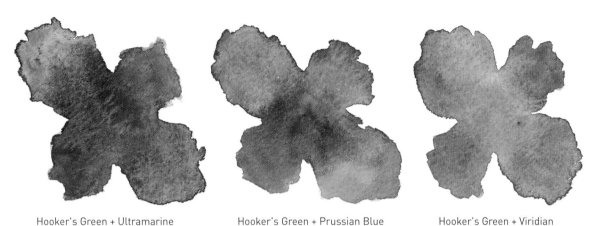

Hooker's Green + Ultramarine

Hooker's Green + Prussian Blue

Hooker's Green + Viridian

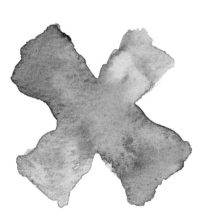

Hooker's Green + Burnt Sienna

Hooker's Green + Vandyke Brown

VIRIDIAN

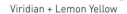

Viridian + Lemon Yellow

Viridian + Cadmium Yellow

Viridian + Cadmium Orange

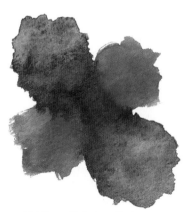

Viridian + Cadmium Red

Viridian + Alizarin Crimson

Viridian + Violet

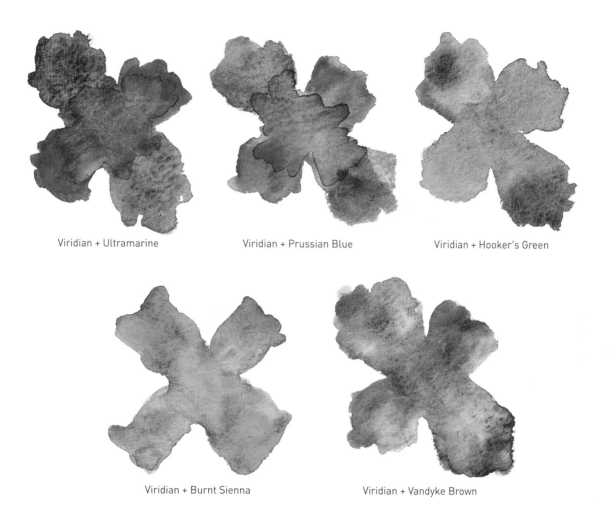

Viridian + Ultramarine

Viridian + Prussian Blue

Viridian + Hooker's Green

Viridian + Burnt Sienna

Viridian + Vandyke Brown

BURNT SIENNA

Burnt Sienna + Lemon Yellow

Burnt Sienna + Cadmium Yellow

Burnt Sienna + Cadmium Orange

Burnt Sienna + Cadmium Red

Burnt Sienna + Alizarin Crimson

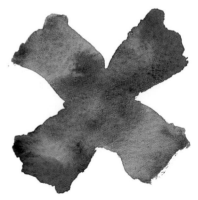

Burnt Sienna + Violet

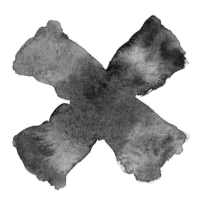

Burnt Sienna + Ultramarine

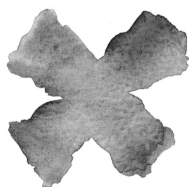

Burnt Sienna + Prussian Blue

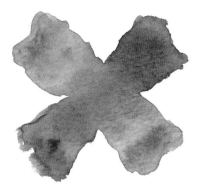

Burnt Sienna + Hooker's Green

Burnt Sienna + Viridian

Burnt Sienna + Vandyke Brown

VANDYKE BROWN

Vandyke Brown + Lemon Yellow

Vandyke Brown + Cadmium Yellow

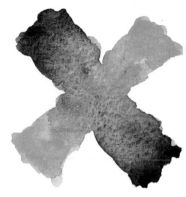

Vandyke Brown + Cadmium Orange

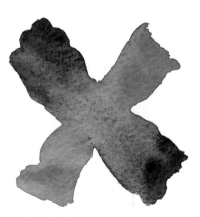

Vandyke Brown + Cadmium Red

Vandyke Brown + Alizarin Crimson

Vandyke Brown + Violet

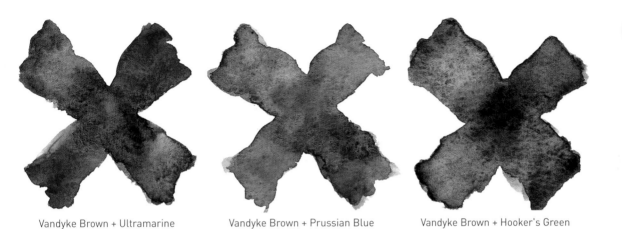

Vandyke Brown + Ultramarine

Vandyke Brown + Prussian Blue

Vandyke Brown + Hooker's Green

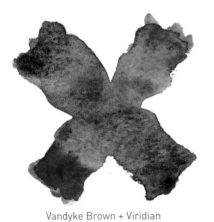

Vandyke Brown + Viridian

Vandyke Brown + Burnt Sienna

PERMANENT ROSE

Permanent Rose + Lemon Yellow

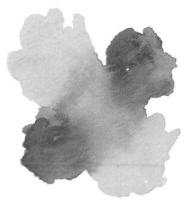

Permanent Rose + Cadmium Yellow

Permanent Rose + Cadmium Orange

Permanent Rose + Cadmium Red

Permanent Rose + Alizarin Crimson

Permanent Rose + Violet

Permanent Rose + Ultramarine

Permanent Rose + Prussian Blue

Permanent Rose + Hooker's Green

Permanent Rose + Viridian

Permanent Rose + Burnt Sienna

Permanent Rose + Vandyke Brown

YELLOW OCHRE

Yellow Ochre + Lemon Yellow

Yellow Ochre + Cadmium Yellow

Yellow Ochre + Cadmium Orange

Yellow Ochre + Cadmium Red

Yellow Ochre + Alizarin Crimson

Yellow Ochre + Violet

Yellow Ochre + Ultramarine

Yellow Ochre + Prussian Blue

Yellow Ochre + Hooker's Green

Yellow Ochre + Viridian

Yellow Ochre + Burnt Sienna

Yellow Ochre + Vandyke Brown

PAYNE'S GREY

Payne's Grey + Lemon Yellow

Payne's Grey + Cadmium Yellow

Payne's Grey + Cadmium Orange

Payne's Grey + Cadmium Red

Payne's Grey + Alizarin Crimson

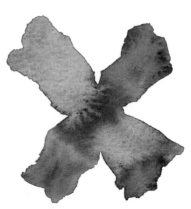

Payne's Grey + Violet

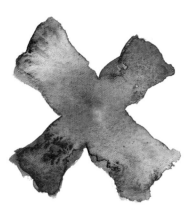

Payne's Grey + Ultramarine

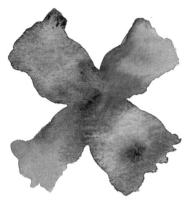

Payne's Grey + Prussian Blue

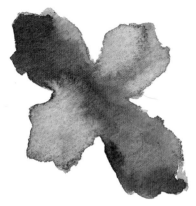

Payne's Grey + Hooker's Green

Payne's Grey + Viridian

Payne's Grey + Burnt Sienna

Payne's Grey + Vandyke Brown

5 NEUTRAL COLOURS

While bright, intense colours are exciting, you need quieter colours too for a change of mood. Mixing your own neutrals will give you a lot of control over the range you use.

Brown and grey mixes

Your paintbox will probably contain some brown pigments, known as earth colours because they are derived from natural clays and other types of earth. These act as neutral colours, ideal for providing subtle tones for foliage and natural stone or brickwork buildings. They are also useful for modifying the effect of brighter colours.

However, mixing your own neutrals from opposite colours on the wheel offers more variety. In the mixes shown here you can see the change from the warm to cool in the mixes. Working on the principle that yellows and reds are warmer while blues, violets and greens are cooler, you can alter the proportions of colour to make warm browns or cool greys.

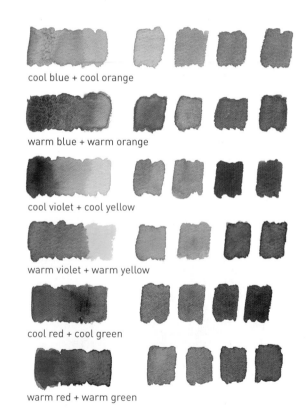

cool blue + cool orange

warm blue + warm orange

cool violet + cool yellow

warm violet + warm yellow

cool red + cool green

warm red + warm green

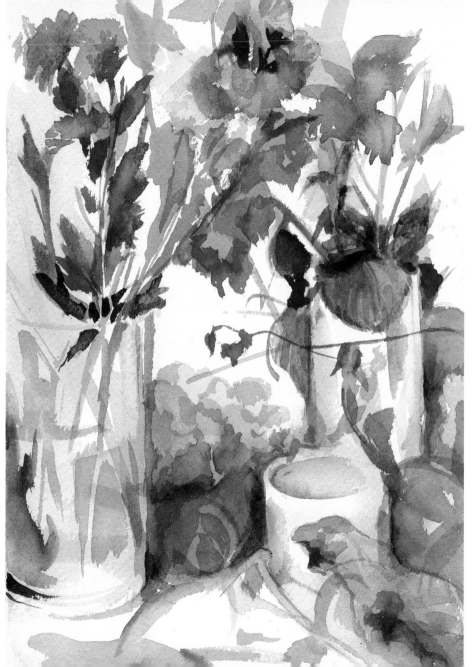

AUTUMNAL BLOOMS

Flowers that are wilting or drying out can provide an interesting take on a popular subject. Neutral browns can be exploited to show the gently fading colours.

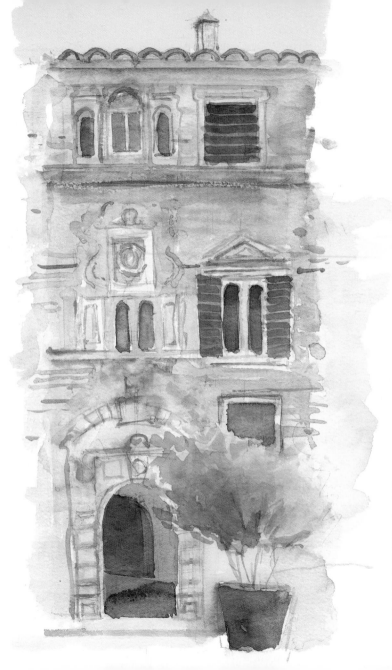

CITY SQUARE

PALETTE USED
Lemon Yellow
Cadmium Yellow
Cadmium Orange
Ultramarine
Permanent Rose
Yellow Ochre
Payne's Grey
Naples Yellow
Raw Sienna

CORNER OF
THE PIAZZA

The neutrals were mixed with Burnt Sienna and a touch of Ultramarine for the doorway and window shutters. For the slatted areas, more Ultramarine than Burnt Sienna was retained in the mix for a harmonious effect.

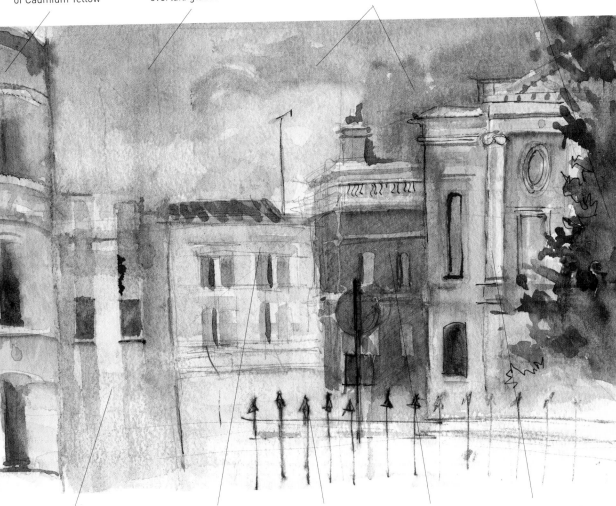

Cadmium Orange with overlaid glazes of Cadmium Yellow

Lemon Yellow and Naples Yellow wash on to damp paper, with overlaid glazes of Ultramarine

Ultramarine on wet paper over Naples Yellow

Ultramarine and Raw Sienna on to damp paper

Very diluted Yellow Ochre and Permanent Rose mix on damp paper

Diluted Naples Yellow with overlaid glazes of Permanent Rose

Brown pen drawn into wet Naples Yellow

Overlaid glazes of Raw Sienna and Permanent Rose mix

Naples Yellow with overlaid glaze of Raw Sienna

Exploring greys

Mixing greys that are distinctive and luminous is possible by using the complementary colours. When you combine any of the primaries with its complementary, the two pigments 'cancel' each other to produce a grey.

There is no need to buy any greys at all – Payne's Grey, which is a very cool blue grey, may be useful in a pan or tube but can equally well be mixed. What you are aiming for is to achieve a choice from very even neutral greys to a wider nuanced selection, so that you can use the most suitable to react against another, brighter colour. You will soon gain enough control to be able to mix both warm, soft greys and cool greys with fluency.

A RANGE OF LUMINOUS GREYS

A subtle painting in muted tones with a 'ping' of brilliant colour is more effective than a painting that is entirely composed of pretty colours. A variety of greys can be mixed from the complementary/primary pairings; not only are they subtle in their differences when seen together, but setting them off with a brilliant colour enhances a painting as the colours are working together rather than competing.

Creating mood and atmosphere is possible with a diverse range of neutrals, and you will soon become familiar with the ratio of colours needed to obtain the effect you want. Below are just a few examples of the possibilities offered by using greys in your paintings.

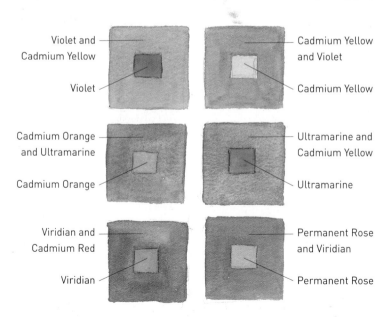

Violet and Cadmium Yellow

Violet

Cadmium Yellow and Violet

Cadmium Yellow

Cadmium Orange and Ultramarine

Cadmium Orange

Ultramarine and Cadmium Yellow

Ultramarine

Viridian and Cadmium Red

Viridian

Permanent Rose and Viridian

Permanent Rose

LUMINOUS GREYS

A variety of greys can be created by mixing a primary with its complementary colour. Setting the resulting grey against one of the colours creates a pleasing contrast.

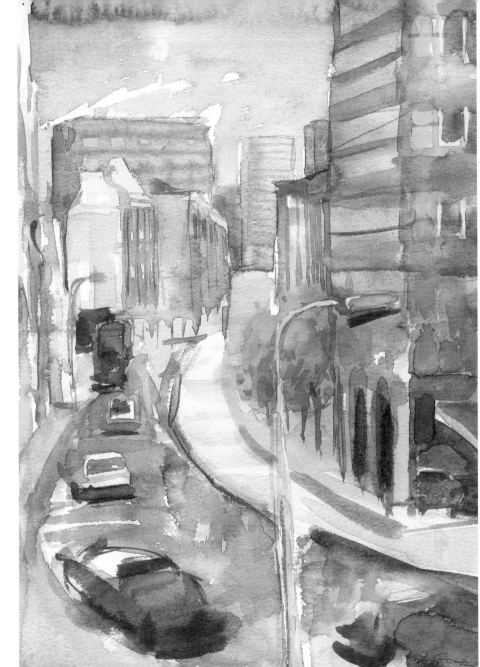

RAINY LONDON STREET

The grey mixes in the road and the puddles were a mixture of Viridian and Permanent Rose. The cars and the browner areas on the buildings were a warmer grey mixed from Cadmium Red and Hooker's Green.

Using black and white

Watercolour sets often contain a black and a white, but these are used differently in watercolour painting from how they are found in acrylics, gouache and oil.

Adding black to a colour to darken it will produce a muddier version rather than a darker value – it is better to use less dilution instead. However, adding a colour to black can make rich, velvety darks. The intention has to be clear – you need to add enough pigment to the black for the dark to show the particular colour you are using, such as blue or red. If you are not bold enough the mix will just look dirty rather than a deeper, richer version of the colour.

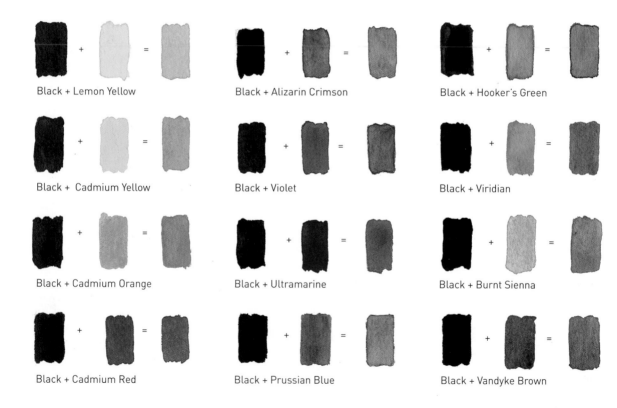

Black + Lemon Yellow

Black + Alizarin Crimson

Black + Hooker's Green

Black + Cadmium Yellow

Black + Violet

Black + Viridian

Black + Cadmium Orange

Black + Ultramarine

Black + Burnt Sienna

Black + Cadmium Red

Black + Prussian Blue

Black + Vandyke Brown

Chinese White is a rather milky white and when mixed with a colour remains semi-transparent so a hazy colour emerges. For opaque white, gouache is a water-based paint that can be combined with true watercolours to make them not only lighter but opaque too. White may also be used unmixed in clouds or glittering sea, for example, to give a touch of light. Applied sparingly, it is very effective.

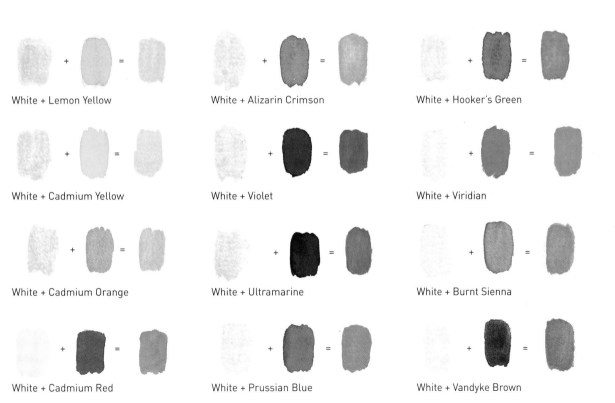

White + Lemon Yellow

White + Alizarin Crimson

White + Hooker's Green

White + Cadmium Yellow

White + Violet

White + Viridian

White + Cadmium Orange

White + Ultramarine

White + Burnt Sienna

White + Cadmium Red

White + Prussian Blue

White + Vandyke Brown

6 COLOUR, LIGHT AND SHADE

The palette you use will depend upon your subject, the time of day and what you wish to convey to the viewer. For instance, a tropical scene will call for bright colours and strong shadows to suggest the heat and blinding sun. At the opposite extreme, a northern landscape on a misty autumn day will test your powers of handing diluted washes and subtle hues.

Contrast

HIGH KEY

Paintings are described as high key on account of their subject matter – for example, a bright bunch of exotic flowers – or because there is a feeling of strong light. The sharper the light, the purer and more dramatic the colours will appear. Bright, clear morning light increases the intensity of the hues, creating more contrast between darks and lights and giving drama.

Afternoon light can bleach out the strength of the colour, making it appear paler and hazier. Using the same pigments, you can simply mix them with a greater dilution of water to create tints of the colour that was so much stronger in the morning.

Making paintings of the same location seen in very different moods depending upon the weather and time of day is a fascinating exercise that will also sharpen up your skills of observation and accuracy of colour mixing.

LOW KEY

In contrast to the bright, saturated colours of high-key pictures, low-key paintings rely on unsaturated washes of colour used with subtlety.

The English watercolourists are famed for their sensitive, delicate colours that owe more to the weather conditions than artistic temperament. The melancholy mood that pervades their landscapes and seascapes reflects the influence of the climate. The misty atmosphere and diffused light reduces contrast so that the tonal range is narrower than where strong darks and lights prevail.

You can still use pure colours in a low-key painting if they are very diluted so that the white of the paper is allowed to shine through or mix them to make neutrals. The neutrals made by mixing the complementaries, which are low key provided that they are used fairly diluted, are especially good for luminous greys (see page 146).

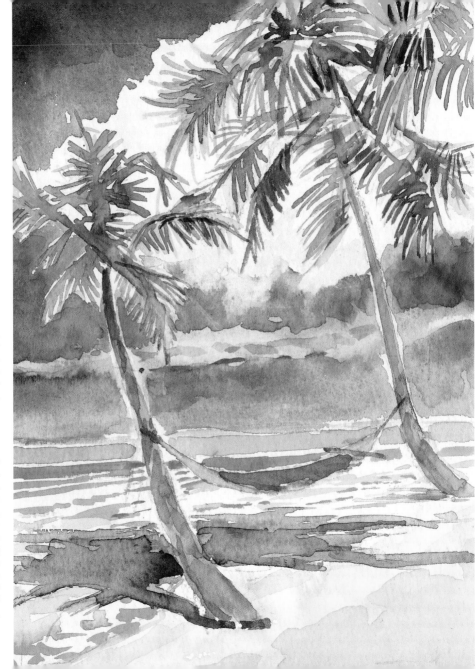

CARIBBEAN HAMMOCK

The light is fundamental to the sharp, clear colours of this high-key painting. The sand is diluted Cadmium Yellow, overlaid with a more intense glaze. The leaves of the palm trees were painted in strong definition, using Prussian Blue and Viridian strokes on wet paper, which was then added to with Cadmium Yellow and touches of Alizarin Crimson.

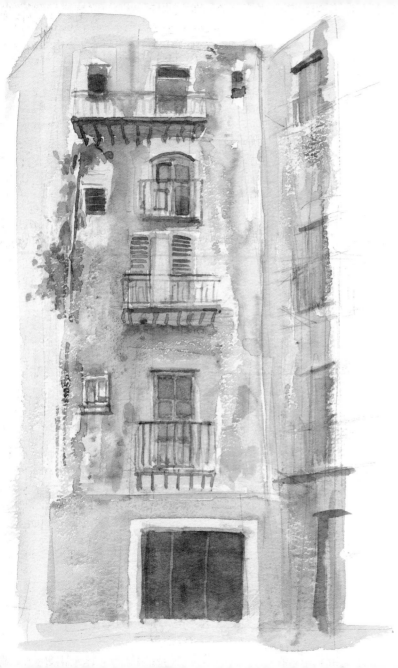

The painting shown right was made on the spot and I exaggerated the colours I could see for greater impact. The bright light gave me the opportunity to use high-key, strong colour and definite contrast. The cool shadows are blue and violet mixes to set off the complementary orange-yellow sunlit walls and roofs.

While also a Mediterranean scene, the street shown left was in mellower light and the actual colours of the stonework were pale and delicately textured. To represent them I used a lower-key range of colours, diluting them more to achieve subtle shades. Even the windows are not painted starkly, to avoid making too much of a contrast and to retain the soft atmosphere.

ITALIAN BALCONIES

The colours are used in a more diluted form than in the painting opposite. Cadmium Orange and Raw Sienna in wet-into-wet offers a softer surface. Prussian Blue is used sparsely and is tonally similar to the warm colours.

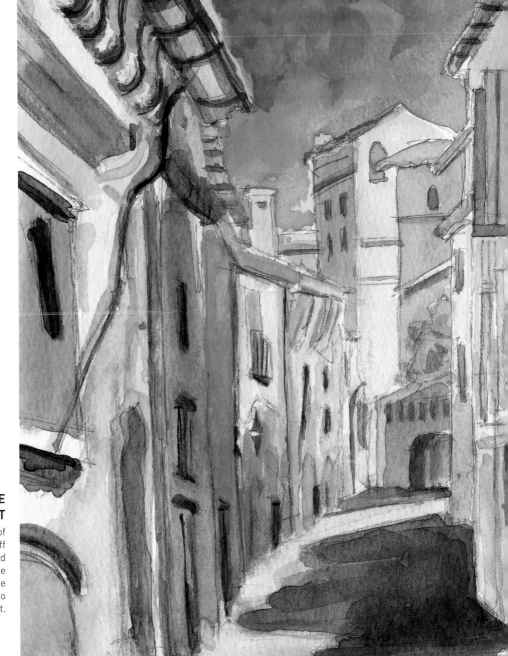

FRENCH VILLAGE STREET

The strong use of Cobalt Blue sets off the warmer yellow and orange walls, while the red door draws the viewer's eye down to the end of the street.

Viridian and Alizarin Crimson mix with overlaid glazes of diluted Payne's Grey

Cadmium Yellow wash with overlaid glazes of a mix of Payne's Grey and Prussian Blue

Diluted mix of Payne's Grey, Prussian Blue and Cadmium Yellow with overlaid glaze of diluted Alizarin Crimson

Payne's Grey, Prussian Blue and Cadmium Yellow mix, overlaid with a glaze of Cadmium Orange

Cadmium Yellow and a touch of Viridian overlaid with a glaze of Prussian Blue

Viridian mixed with very diluted Alizarin Crimson

Cadmium Yellow and Alizarin Crimson mix with overlaid glazes of Payne's Grey and Prussian Blue

REFLECTIONS

PALETTE USED
Cadmium Yellow
Cadmium Orange
Alizarin Crimson
Prussian Blue
Viridian
Payne's Grey

Cadmium Yellow wash overlaid with brushstrokes of Payne's Grey

Cadmium Yellow and Alizarin Crimson mix with overlaid glazes of Payne's Grey and Prussian Blue

Hooker's Green and Lemon Yellow mix with overlaid glaze of Hooker's Green

Cadmium Yellow brushmarks allowing white of paper to show through

Overlaid glazes of Burnt Sienna

Hooker's Green with a touch of Prussian Blue

AZALEAS AND RHODODENDRONS

PALETTE USED
Lemon Yellow
Cadmium Yellow
Cadmium Red
Prussian Blue
Hooker's Green
Viridian
Burnt Sienna
Permanent Rose

Diluted Cadmium Red applied wet-into-wet with diluted Viridian

Lemon Yellow on dry paper

Permanent Rose applied wet-into-wet with Cadmium Red

Cadmium Red applied wet-into-wet with Cadmium Yellow

Light and shade

The term 'colour temperature' describes how warm or cool a colour is. As you have discovered, red, orange and yellow are generally regarded as warm, while blue, green and violet are seen as cool. However, to gain a more nuanced understanding it is worth spending some time studying the qualities of the named colours used in the mixes on pages 40–141 to gain control over your pigments and use them appropriately.

Yet what really determines the warmth or coolness of a given colour in a painting is the colour of the prevailing light, the reflected light from nearby surfaces and the sky itself. Late afternoon sunlight tinges subjects with a warm glow and shadows are contrastingly cool. A winter's day often has a bleached sky that drains the colour. Artificial light has its differences; the traditional incandescent bulbs shed warm yellow light whereas low-energy bulbs are colder and fluorescent lighting is greenish cool. These paintings of cricketers show the way light affects the subject depending on the time of the day.

Always observe the light carefully so that you can convey an impression of a particular place and time of day successfully. You may need to make a positive effort to avoid just painting what your brain tells you; for example, you may know that a tree is green, but it will be affected by the light so it may become more yellow in sunlight or more blue in shade.

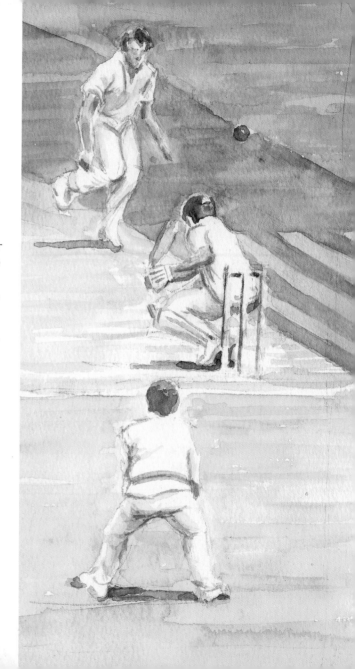

CRICKETERS, NOON

At noon the sun is bright in a cloudless day and there are very clear contrasts. The colour is washed out in the lit areas with hard, cool light and the shadows are dark and neutral. If there is some cloud then the shadows will be less obvious and thus slightly more colourful.

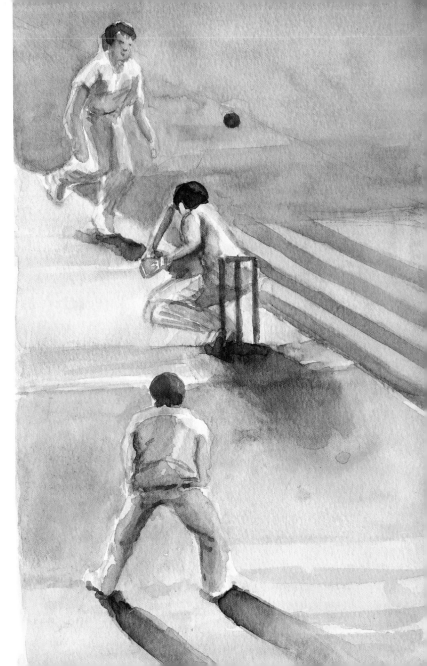

CRICKETERS, EVENING

In the evening the sun is closer to the horizon and less bright, giving a glow of warm light. The whites of the cricketers look purple-bluish in the shadows. All the shadows appear much longer because of the low angle of the sun.

EARLY EVENING, SUMMERTIME

To create a sense of distance in a landscape it can be helpful to use very diluted cool washes in the background, moving to stronger, intense colours in the foreground. Here, warm orange in the foreground and blues and blue-greens in the background add to the three-dimensional feel.

A landscape in strong sunlight, such as this, with contrasts of highlight and shadow is made more powerful by the use of saturated colour.

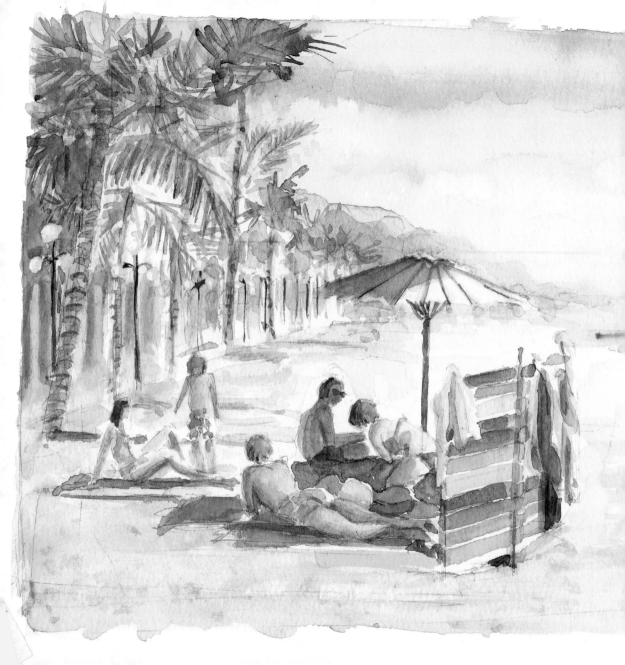

MEDITERRANEAN BEACH

The beach as a subject always provides plenty of opportunities to use high-key colour. Windbreaks, parasols and towels are all usually brightly coloured, while the light on the sand and sea is always striking and lends the scene a particular intensity.

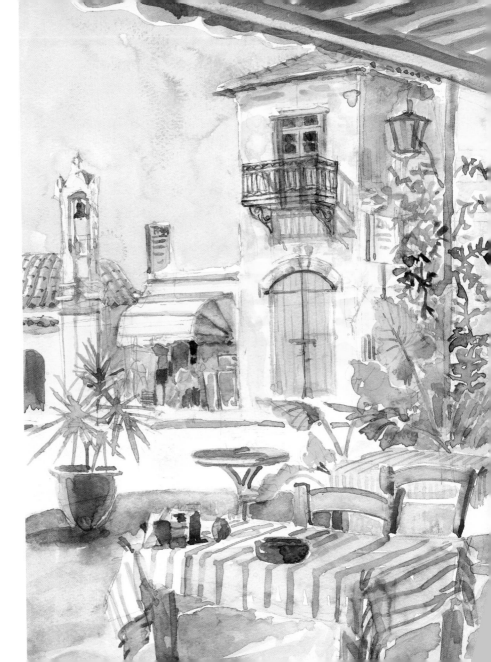

CAFE, CYPRUS

The contrast of the partially shaded table area and the strongly lit square provide plenty of examples of high-key colour. The tablecloth stripes were painted in strong Cadmium Red, slightly diluted in the folds.

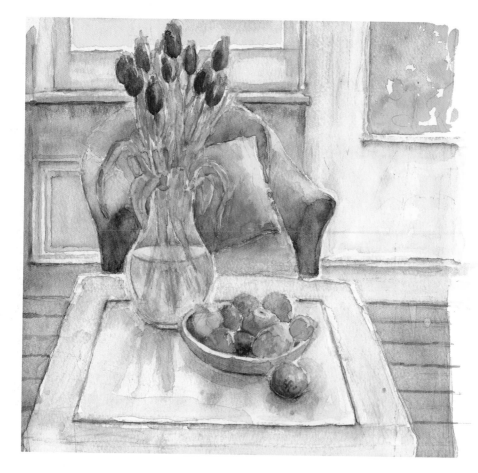

Although the sun is not shining directly into the room, the table is bathed in light and there is a subtle halo of light on the edge of the chair as it is nearest the window.

Not only is the appearance of objects affected by the prevailing light, it is also influenced by their surroundings and the reflections they cast – especially in the case of white surfaces, as you can see in the painting above, where the 'white' is full of colour.

If you choose a viewpoint where the light is coming from behind your subject, be it an interior view or a landscape, colours are darker and more intense and objects often appear to be rimmed with light. This is called *contre jour*, which, literally translated, means 'against the day'. Here again, although in reality the objects may be quite light in colour, they will alter visually in response to the particular situation.

OUTSIDE INSIDE

Usually interiors appear darker when painting the outdoors from inside because of the contrasting brightness through the window. Here, however, the sun hits the edge of the objects, defining their shape and creating silhouettes in contrast to the less-defined exterior.

7 FINDING YOUR SUBJECT

At first you may wonder where to find your subject matter. In fact, it can be anything at all; an interesting painting comes from your approach and use of colour.

If the emphasis is on strong colour, make an impact by using high-key colours in your painting. This could be a still life composed of brightly patterned textiles and exotic plants or a beach scene with umbrellas, towels and people in typical primary colours. In garden scenes, pattern and shape can be exploited in deckchairs and flowers. Light plays an important role; applying the paint in intense, smaller brushstrokes, letting the white of the paper show in between marks, creates more contrast and thus stronger 'pings' of colour.

If you want to express a mood of tranquillity, go for a subtle painting with low-key mixes such as a misty autumn landscape or a corner of a lamp-lit room, painted in washes and glazes. Let the colours flow and mingle by painting wet-into-wet for a range of modified colour and diffused edges.

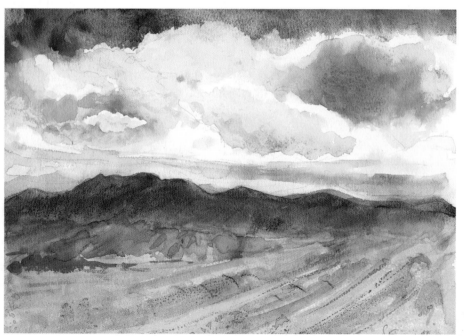

MOUNTAIN SKY

Skies are difficult to capture but perfect for the speed and fluidity of watercolour. Here the sky is transparent while the landscape is colourful and vibrant.

DEEP SKY

This is more about sky than landscape, though the diminishing river and trees provide a sense of space. The clouds are achieved by leaving areas of white paper showing, then adding brushtrokes of grey to give them solidity. Vigorous brushstrokes add a sense of movement to the sky.

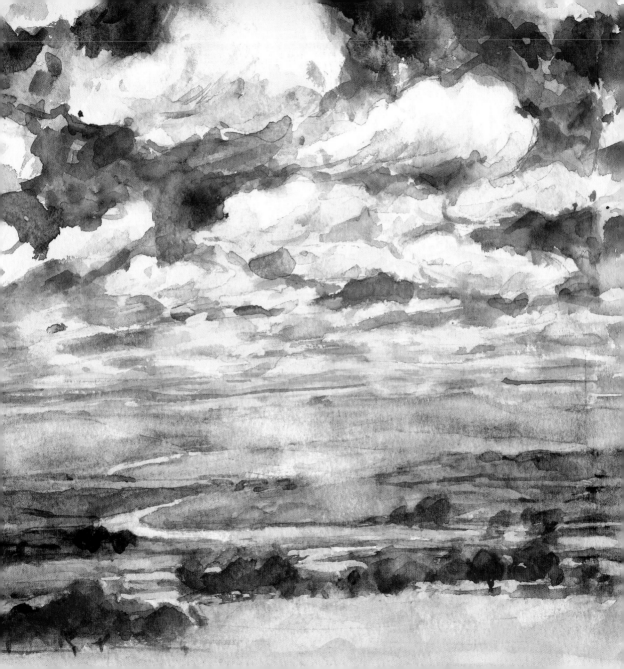

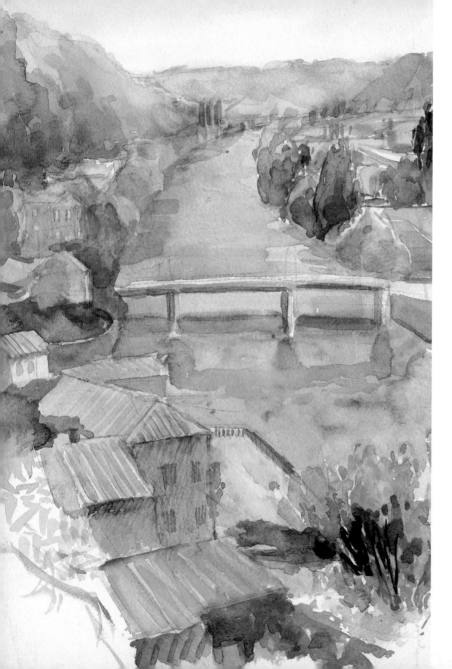

Landscape

You may not live in an area of stunning landscape, but even so you will probably have access to parks or other open land that will allow you to paint the natural world. The colours you use will depend on the light and season and whether you are painting a detail or aiming for a feeling of space.

Even in winter, landscape will challenge you with a variety of greens. While this may seem tricky, it means you will be using a limited palette, which pulls a painting together.

LOT VALLEY, FRANCE

The winding river helps this painting to achieve a sense of depth, while the rooftop tiles in the foreground provide contrasting detail.

TUSCAN HILLS

The defined line of olive trees – painted in a Naples Yellow and Prussian Blue mix – lead into a vast landscape of low hills, which were painted on very wet paper to suggest distance.

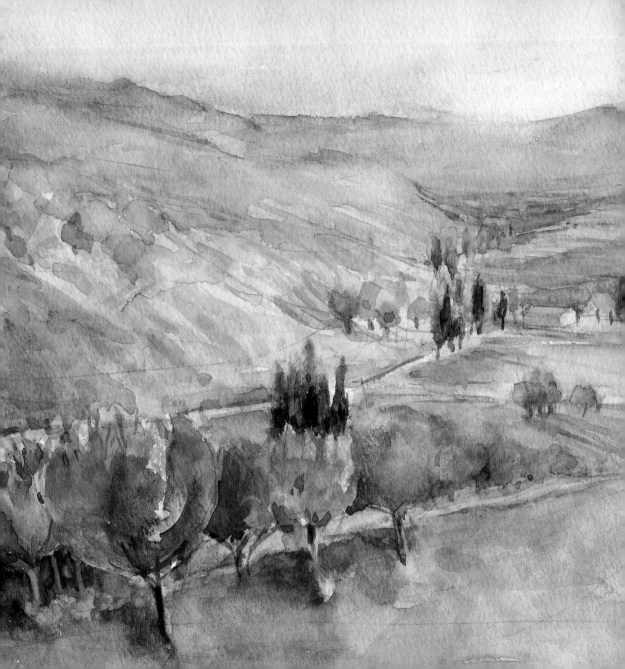

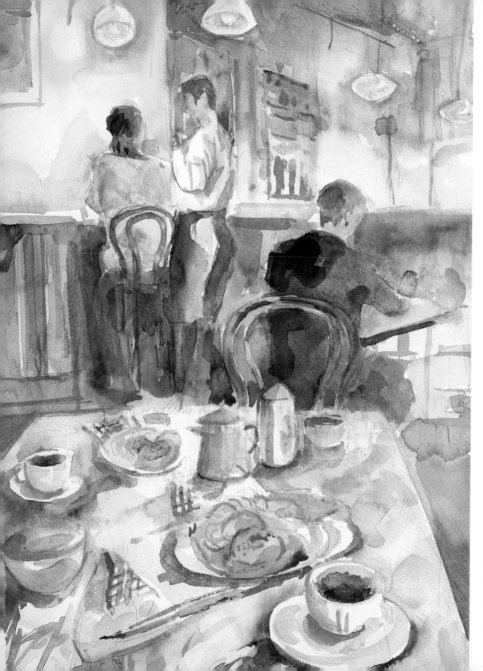

Still life

A still life can be anything from a bowl of beautiful fruit in harmonious colours to the contents of a handbag scattered in an interesting fashion. In public interiors the light may be lower and the colours of the furniture may be neutral, but it is where and how to express the shadows that is the colour challenge; rather than rely on a paint manufacturer's choices of grey, mix your own unusual greys.

CAFÉ BREAKFAST

The white cloth offers a good opportunity to create interesting shadows, leaving the paper white for the lightest areas. The gentle glow of the bar area is achieved with a combination of Alizarin Crimson, Cadmium Yellow and Naples Yellow paint blended on a wet surface.

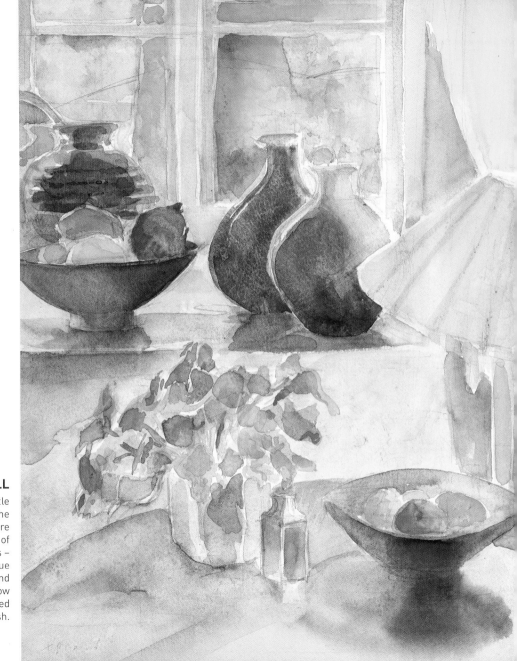

WINDOWSILL

Here there is a subtle interplay between the colours, which are gentle versions of complementaries – orange and blue alongside yellow and violet. The shadow edges are softened with a damp brush.

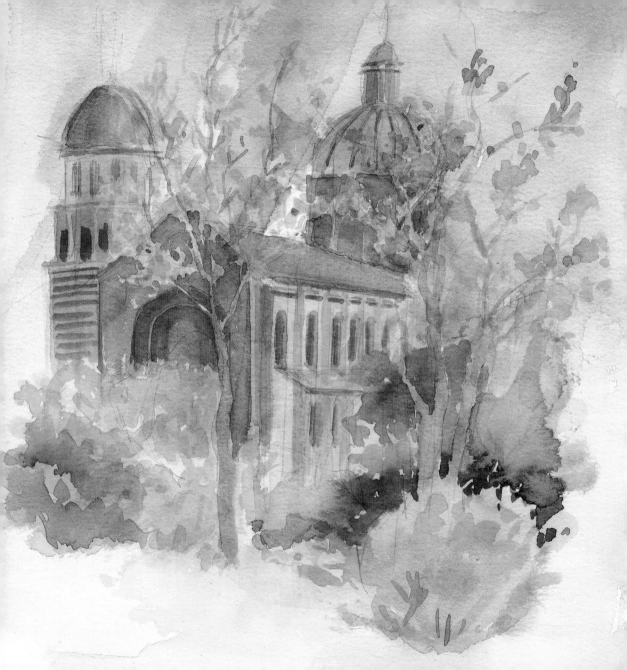

Buildings

In the case of buildings, colours are likely to be neutral – think of stone, brick, concrete and even steel and glass. Rather than relying on a manufacturer's pigments, mix unusual greys and browns of your own (see pages 142–147). Shadows in an urban scene are likely to be solid and hard-edged, since they are usually cast by other buildings; if the buildings are surrounded by trees, the shadows will be more diffuse and subtle. Remember, though, that even the darkest shadow on an urban building will have colour in it, which you can either discover by observation or decide yourself to suit the rest of your painting and the mood you wish to create.

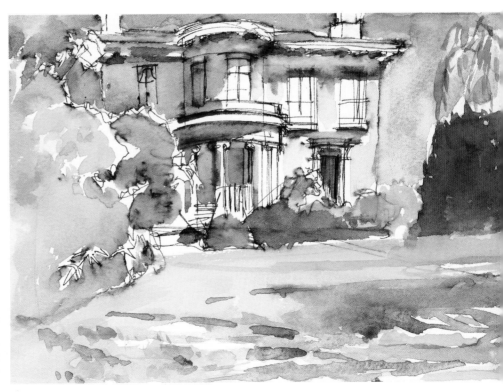

CHURCH WITH DOME
The need to be architecturally correct can be bypassed by using the surroundings effectively. The hard edges of this church were softened by the trees and foliage.

HOUSE WITH PORTICO
A water-soluble pen was used to depict the building structure. It was then blended with watercolour to create shadows without compromising the architectural details.

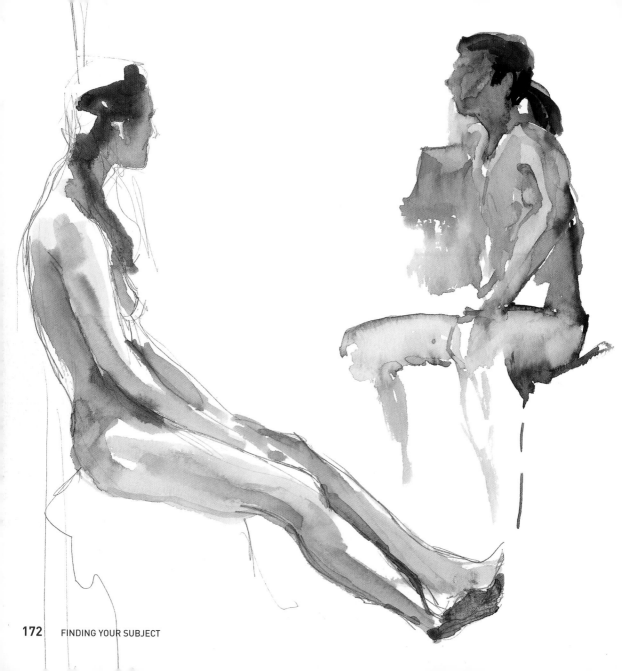

People

People present the most challenging subject because unless you can persuade them to pose for you they usually keep changing their position, even if they are sitting down. This is where taking photographs and sketching on the spot are very helpful. In fact, using them for reference rather than painting directly from observation of the subject can be a very liberating process; referring to the images as an inspiration rather than an accurate representation can push you to develop your own personal language, particularly if you exaggerate and alter the colours instead of merely copying them. Combining all of the visual material can be a voyage of visual discovery.

RELAXED FIGURES

The shadows – a mix of Alizarin Crimson and Vandyke Brown – are strong and exaggerated in these figures. Sometimes there is more of one colour in the mix than the other, indicating whether a limb is behind or in front of another limb.

EGYPTIAN MAN

A passing figure is a challenge to capture. A swift wet-into-wet approach does the trick, using violets and blues against a warm yellow-brown wall.

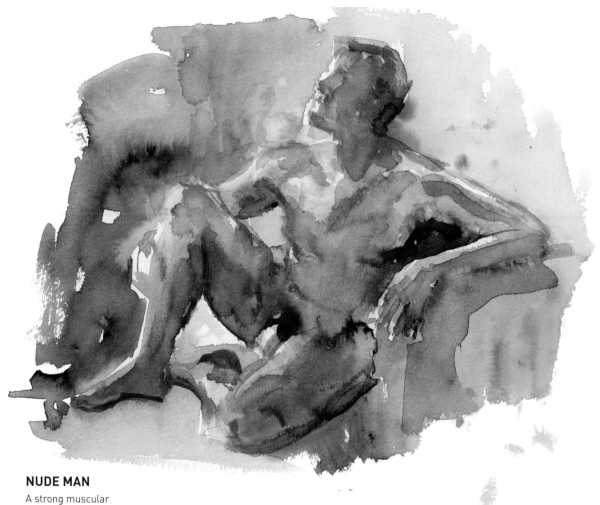

NUDE MAN

A strong muscular
figure needs to be
painted using several
layers of colour to
emphasize the way the
limbs twist and turn.

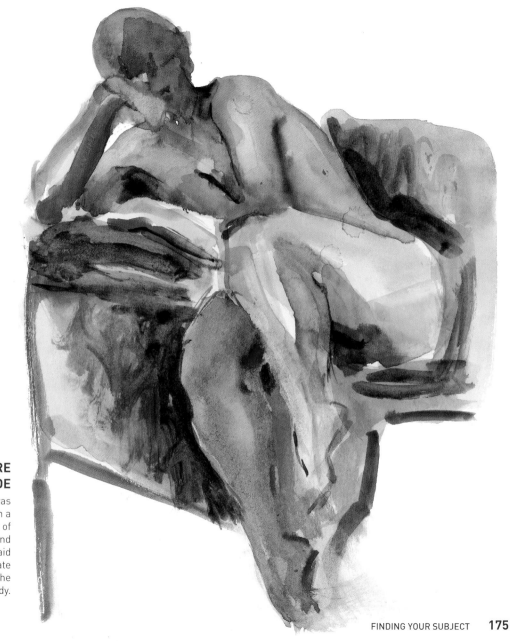

DEMURE WOMAN NUDE

This figure was painted in a combination of wet-into-wet and clear overlaid glazes to indicate shadows on the limbs of the body.

INDEX